IMAGES
*of America*

# IPSWICH

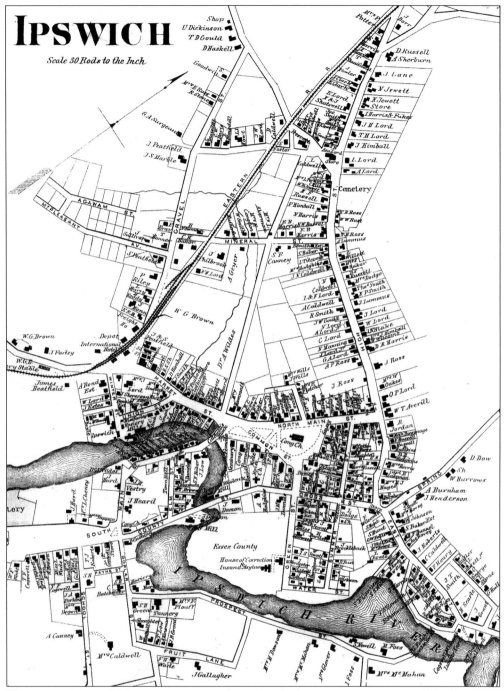

This map of Ipswich Center represents the individual property owners in 1872. (Courtesy Ipswich Public Library.)

IMAGES
of America

# IPSWICH

William M. Varrell for the
Ipswich Historical Society

ARCADIA

First published 2001

Published by Arcadia Publishing,
Charleston SC, Chicago IL, Portsmouth NH, San Francisco CA

Printed in Great Britain

Library of Congress Catalog Card Number: 2001089661

For all general information, contact Arcadia Publishing:
Telephone 843-853-2070
Fax 843-853-0044
E-mail sales@arcadiapublishing.com
For customer service and orders:
Toll-free 1-888-313-2665

Visit us on the Internet at www.arcadiapublishing.com

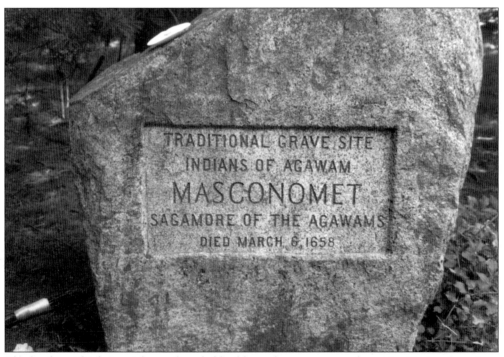

The land on which Ipswich was founded had been for many years the major Native American community of Agawam. As Capt. John Smith described it in 1614, "Here are many rising hills, and on their tops and descents are many corne fields and delightfull groves." Most of the Native Americans died during a 1617 epidemic, but on Sagamore Hill in Hamilton, part of the original Agawam, is the impressive grave of Masconomet, last sachem of the Native American community we now call Ipswich. (Ipswich Historical Society.)

# CONTENTS

# FOREWORD

We of the Ipswich Historical Society are very fortunate to have Bill Varrell among our ranks of members and volunteers. He brought to the compilation of this book enthusiasm, knowledge, hard work, and a sense of humor that made him a pleasure to work with. He has done a superb job of using photographs to present a comprehensive picture of Ipswich's past. We are indebted to him, and to all those who helped him, for making this book possible.

In its second century, the Ipswich Historical Society remains committed to its goal of preserving and sharing the history and art of Ipswich with residents and visitors to town. This book carries our mission in two ways. First, it shares historical views of Ipswich with a wide audience. Second, the Ipswich Historical Society's proceeds from the book go to support preservation of our archives. We hope you enjoy *Images of America: Ipswich* and thank you for your support of our work.

—Stephanie R. Gaskins
President, Ipswich Historical Society

# INTRODUCTION

Ipswich, Massachusetts, first settled by Englishmen in 1633, is one of the oldest towns in this country and has more First Period houses still lived in than any other community in the United States. Currently, Ipswich has more than 55 houses that are documented by professionals to have been built during what historians refer to as the First Period, or during the 100 years between 1625 and 1725.

Almost as important as the old buildings is the fact that such a significant part of the local landscape remains much as it was when the first settlers arrived. Not only does the Ipswich River still picturesquely bisect the town, much open land still remains between the town and the sea and Willowdale State Forest contains much of the town's woodlands. Also remaining as they appeared to Ipswich's earliest inhabitants are most of the salt marsh along the shore and Plum Island and the secluded dunes at Crane's Beach, still reflecting the tide-washed grandeur.

Much that has not changed for over 350 years results from the fact that, after the 18th century, Ipswich's growth did not keep up with that of the rest of its neighbors. Before the American Revolution, Ipswich shared its prominence as a seaport with Salem and Boston; however, after the Revolution its narrow, shallow river could not compete with the larger and deeper harbors of the nearby seaports. Its sea captains and China traders continued for several more generations, but out of other ports with better facilities. In the 1830s, Ipswich thought that the railroad might enhance its prosperity, but the railroad immediately eliminated the need for an overnight stop between Boston and Portsmouth, New Hampshire, and carried the cargo that Ipswich had previously supplied to its neighboring communities. Although Ipswich had been the lace capital of the new nation and, later, its hosiery capital, it had only one major mill. Its neighbors on the Merrimack River had dozens of mills and became cities, while Ipswich made do with what it had and remained a town. In many respects, this village that slept through several generations of industrial growth avoided many of the negative results of growth, enabling it to have the best of both worlds that we enjoy today.

Reflecting Ipswich's importance in our country's history, the earliest years of the town's history are extremely well documented. The Ipswich Historical Society maintains two important house museums, and four major museums—the Metropolitan Museum of New York, the Boston Museum of Fine Arts, the Winterthur Museum, and the Smithsonian—exhibit significant rooms, furniture, and artifacts from Ipswich's earliest days and first craftsmen. Frequently referenced authors, such as Joseph B. Felt and Thomas Franklin Waters, published important histories that document in great detail all aspects of the local people and their daily

lives. In more recent times, local historians Mary Conley and Louise Best updated the town's Catholic history, the engaging style of Alice Keenan introduced all to the most colorful personalities and characters from the town's past, and the articles of Harold Bowen shared his hundreds of details of local life. In addition, Nancy Weare and Richard Betts described what it was like being inhabitants of the local summer shores, and Stephanie Gaskins introduced the town's local artists. Also, Sue Boice shared her many photographs in books and cards, the town's saga became part of the best-selling fiction of John Updike, and William and Sidney Shurcliff provided intimate tales of the social elite at the doctors' summer colony on Argilla Road.

So, some will say, what is left to do? Most have heard the old adage that a picture is worth a thousand words, and that is the focus of this book. Unfortunately, there were no cameras to record the first 200 years of the town's history. There are few known photographs of Ipswich taken during the first 30 years of photography but, from the days immediately following the Civil War, Ipswich had a number of professional photographers who captured the town's landscape, real estate, triumphs, and tragedies.

The Ipswich Historical Society's fine, unpublished photograph collection omitted certain subjects, especially more recent events that did not seem significant at the time they occurred. In the daily passage of time, some things that did not appear to be changing were, in fact, changing. Fortunately, Ipswich's Bill George has made collecting old Ipswich photographs a lifetime hobby and has generously shared his fabulous collection to help bring old Ipswich back to life. In addition, other institutions and less well-known collectors have added their missing pieces to the important tapestry of local events. The stories told by the images themselves have been supplemented by details gleaned from the author's extensive reading of early newspaper accounts and Ipswich Town Reports.

When Thomas Franklin Waters's histories of *Ipswich in the Massachusetts Bay Colony* were published in 1905 and 1917—as was the case with most local histories written at that time— many incidents were thought too well known or mundane to be included. Similarly, this book will probably make the same omissions. However, this exciting collection will attempt to make all who read it more familiar with the place of this community in the national saga, and let the pictures speak for themselves with the many details that might previously have been overlooked. The ebb and flow of Ipswich history is so strong that a single volume can only scratch the surface. Hopefully, this book will also be the catalyst that will bring other unknown gems of the town's pictorial past to the attention of those who maintain the town's history for future generations.

# One

# FIRST PERIOD

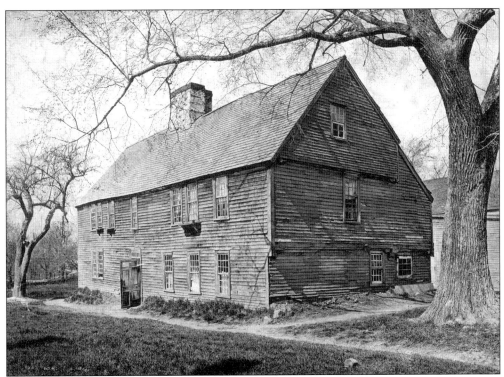

The Whipple House is the crown jewel of Ipswich's First Period houses (1625–1725). This house was home to three generations of Whipples and several more generations of collateral descendants. The left side of it was built *c.* 1655, and the right side was added *c.* 1670. It is shown here as the tenement house that it was when purchased for the headquarters of the Ipswich Historical Society in 1898. (Ipswich Historical Society.)

John Winthrop Jr., with 12 others, led the Puritan settlement of Ipswich in 1633. After his wife died in 1635, he left Ipswich, started the Saugus Ironworks, and later became the governor of Connecticut. Direct descendants of the first John Winthrop still live in Ipswich. (Ipswich Historical Society.)

This photograph by Ipswich artist Arthur Wesley Dow shows the causeway on Jeffreys Neck Road. Before the Winthrop settlement of Ipswich, William Jeffreys, a member of the original Plymouth Colony, lived on Great Neck, where he was involved in European fishing interests. The Puritans forced him to leave but in the road named for him, between the early Puritan community and the ocean, Jeffreys endures. (Ipswich Historical Society.)

In 1953, during a major restoration of the Whipple House, the sheathing was removed to reveal its original frame. This 1655 section of the current museum house shows the sill-to-rooftop studs and the brick nogging that formed the walls. This earliest English-style construction probably had no boards on the outside walls, clapboard siding having being nailed directly to the frame. (Zaharis Studio, Ipswich Historical Society.)

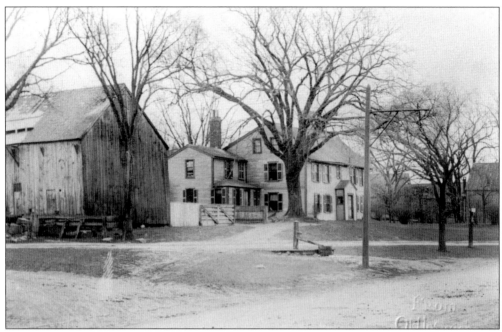

Although updated over the years, recent scholarly research indicates that the Merchant-Choate House at the corner of High Street and Town Farm Road is probably the oldest house in Ipswich still standing. Its present structure contains the frames of two so-called "planter's cottages," built sometime before 1653. (Ipswich Historical Society.)

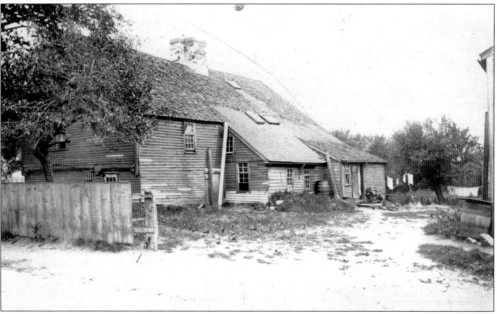

This is the back of the Whipple House as it appeared when purchased by the Ipswich Historical Society in 1898. The historical society realized that the house, no longer comfortable as a residence, would join the list of the other early houses recently torn down if not rescued as a museum. It was then located on Saltonstall Street in what is now the Ebsco parking lot. (Ipswich Historical Society.)

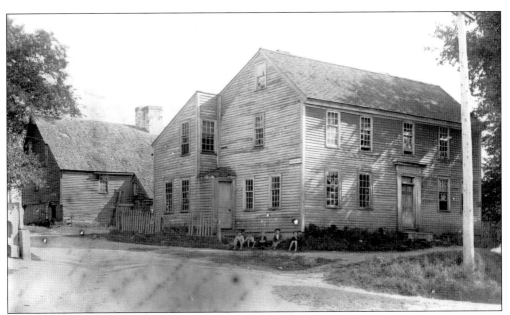

At the time the Whipple House was acquired by the Ipswich Historical Society, this house was located between it and the railroad station. Joseph Baker is said to have moved the house there from its original location near the Meeting House Green after the railroad was built nearby. The age of the house is indicated by the change in its original roofline and the pitch over the "Beverly jog" addition. (Courtesy Society for the Preservation of New England Antiquities.)

This is another view of the house above. Well known for his research of most of the early houses in Ipswich, historian Thomas Franklin Waters says little about this property except that it was a dilapidated eyesore detracting from the appearance of the Whipple House. It was torn down shortly after the Ipswich Historical Society acquired the property in 1899, and the barn was torn down in 1902. (Courtesy Society for the Preservation of New England Antiquities.)

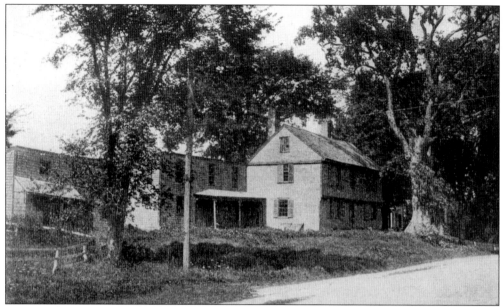

Although research has shown that Richard Saltonstall had no connection with the Whipple House, this, the Thomas Norton House, was built on Saltonstall property in 1723, across from what is now Giles Firman Park. It was used as the jailer's house when the jail was on the adjoining land, before the Ipswich County Jail was built on Green Street in 1828. The wing was the shoemaker's shop of Asa Brown. This house was torn down in 1903. (Ipswich Historical Society.)

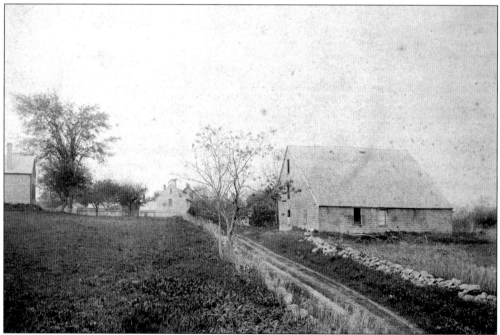

The First Period Daniel Hovey House was located on Tansy Lane off Turkey Shore Road (then called Prospect Street.). Built in 1668, it was last used as a hay barn until it burned in 1894. (Ipswich Historical Society.)

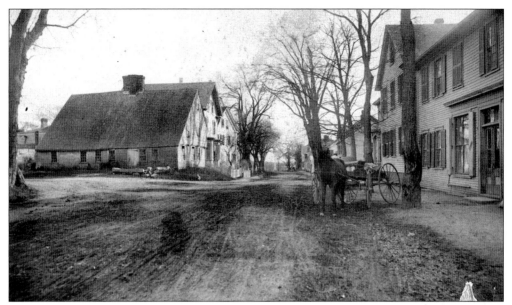

This view of North Main Street was taken looking toward the Meeting House Green. On the left it shows the house said to have been built by "mariner" William Donnton c. 1660. Later called the Dodge House for a family who lived there from 1775 to 1888, it was torn down in 1888. The storefront of the Albert P. Hills grocery store is on the right. (Ipswich Historical Society.)

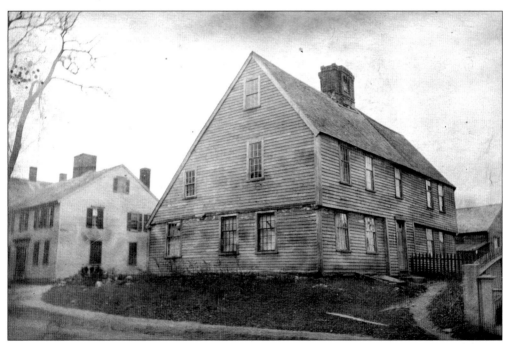

This is the front façade of the Donnton (Dodge) House, which was on the corner of North Main and Summer Streets. In 1888, it was purchased by Theodore Cogswell, treasurer of the Ipswich Savings Bank, who tore it down and replaced it with a home for his daughter when she married George Farley of the Farley and Daniels Shoe Company. (Ipswich Historical Society.)

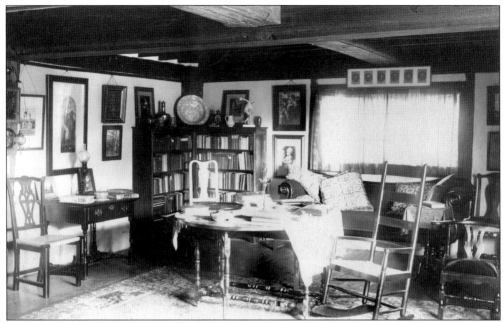

This shows the parlor chamber of the Whipple House as it appeared shortly after it opened as a house museum in 1899. Since it was one of the first house museums in America, there were few standards to determine how it should be interpreted. Over the years it has evolved into a more accurate representation of 17th-century life in Massachusetts. (Ipswich Historical Society.)

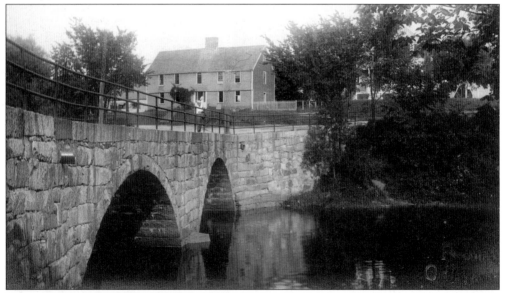

The so-called Emerson-Howard House at the Turkey Shore end of the Green Street Bridge was probably built by William Howard c. 1700. In 1902, to prevent its demolition, it was acquired by Ipswich artist Arthur Wesley Dow, restored, and used as the home of Dow's Ipswich Summer School of Art. In 1929, his widow conveyed it to the Society for the Preservation of New England Antiquities. The society, in turn, sold it back to private owners in 1981. (Ipswich Historical Society.)

The Hart House, built in 1640, had been a residence of the Hart and Kimball families until purchased by antiques dealer Ralph Burnham in 1911. Burnham and his wife operated it as a gift shop, summer inn, and tearoom, and he added the eclectic architecture of the guest rooms. The place became a family restaurant in 1938, after being purchased by Arthur Edes, program manager of Boston radio station WEEI. Edes added the Second Landing, a longtime popular watering hole. (Ipswich Historical Society.)

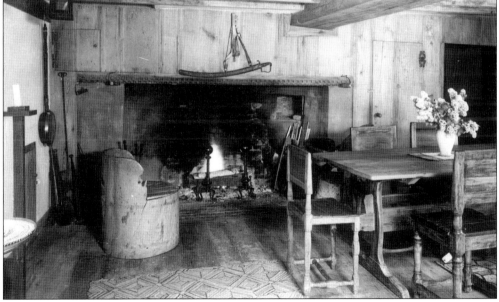

During the 1930s, the paneling from several of the Hart House rooms was copied and the originals were sold to major museums. One room went to the Metropolitan Museum of Art in New York, and the other went to Winterthur Museum. This postcard shows how the Metropolitan interpreted 17th-century rooms at that time. (Courtesy Martha Varrell.)

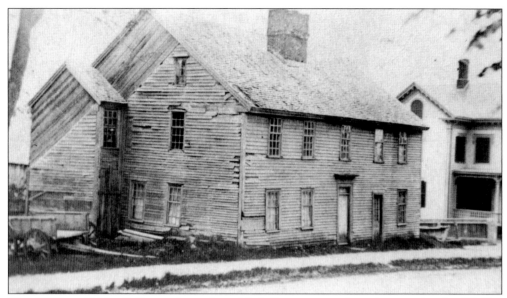

The William Caldwell House, located on High Street approximately opposite the Waldo-Caldwell House, is an indication of why the *Salem Evening News* in 1879 described Ipswich as a town commonly referred to as "Gone to seed." Clearly shown here, the ridgepole had been raised and the interior subdivided. The *Ipswich Chronicle* reported that the house was a firetrap that endangered the surrounding properties. The house was torn down during the summer of 1879. (Courtesy Bill George.)

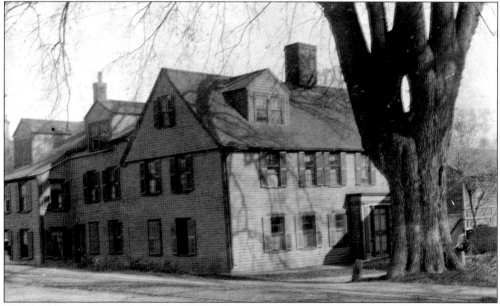

This building was constructed *c.* 1700 and was moved sometime between 1734 and 1736 to a lot at what was to become the south end of the Choate Bridge. Best known as the Ross Tavern, beginning in 1809 it was operated by Jeremiah Ross, when Ipswich was a stagecoach stop and was often bustling with transients attending the local courts. It was moved once more to Jeffreys Neck Road in 1940 and was restored to its First Period condition by Daniel Wendel. (Ipswich Historical Society.)

# Two

# VILLAGE AND TOWN

This view taken from Market Square shows Ipswich Town Hill as it appeared c. 1880. The trees are now gone, as is the store on the left, where Charlie Brown sold gas stoves and Raymond Richards later had a harness shop. The Gothic-style church burned and has been replaced, and although the horse trough is gone, the other buildings and the rocky ledge remain the same today. (Courtesy Tommy Markos.)

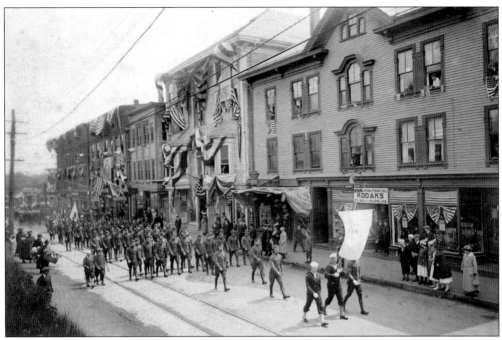

At the time this picture was taken in 1919, the buildings on Central Street looked much as they do today. Apparently this parade of local veterans was celebrating the first Armistice Day, commemorating the end of World War I. (Ipswich Historical Society.)

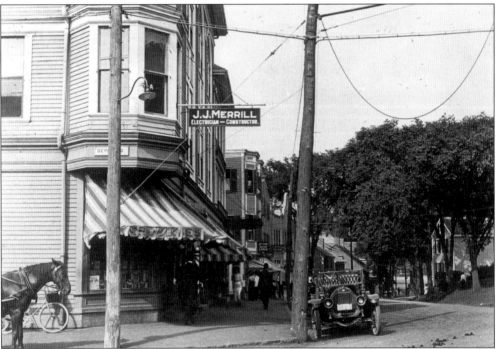

For a town that was often described as "over the hill," this up-and-coming 1909 scene was taken looking down Market Street from the corner of the second Damon Building. Notice the fancy touring car on the corner. (Ipswich Historical Society.)

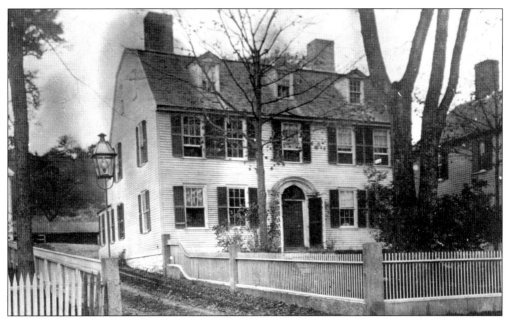

This is the Rogers Manse, built by the Reverend Nathaniel Rogers in 1727. Its extraordinary staircase and the segmented pediment of its entry were created by Capt. Abraham Knowlton, an Ipswich cabinetmaker. As well as being a parsonage for many years, it was a Colonial tavern and the winter home of John Burnham Brown, who was also the owner of Castle Hill Farm. In the early 1900s, it was owned by Joseph H. Burnham, who operated it as the well-known first-class inn and restaurant Ye Rogers Manse. (Ipswich Historical Society.)

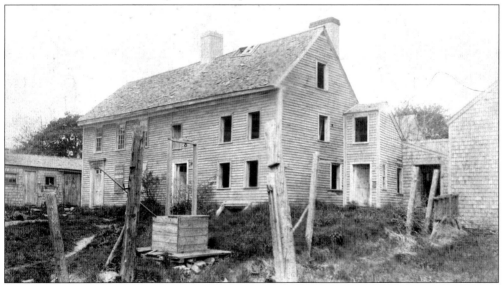

The Harry Maine House was located on Water Street. Some say Harry Maine was a pirate, and others list him with a band of outlaws called "wreckers," who built bonfires on the beach to lure boats ashore and then plunder their cargo. Legend says that, as punishment, Maine was chained to the Ipswich Bar with a shovel and sentenced to shovel the shifting sands for eternity. On stormy nights when waves can be heard crashing across the Ipswich Bar, the devil is said to be "Raisin' the Old Harry." (Ipswich Historical Society.)

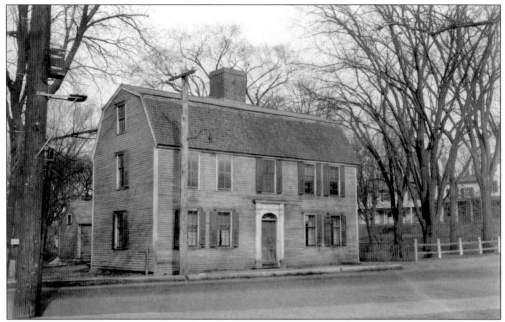

This house on South Main Street, known as the Sally Choate House, stands on what is now the site of the Ipswich War Memorial. Part of the Heard estate, in 1938, the house was purchased by the town and torn down after Alice Heard threatened to sell the property for use as a gas station. (Ipswich Historical Society.)

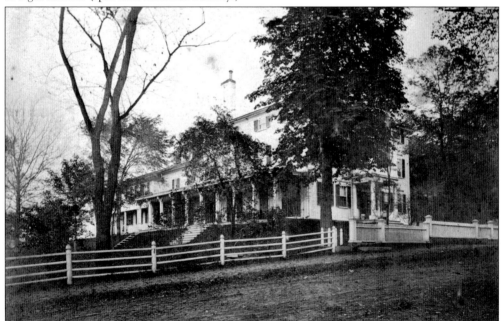

During the 19th century, the Heard Mansion was the summer home of Augustine Heard and the extended family of his brother, George Washington Heard, whose winter home was at 3 Park Street in Boston. The last Heard to occupy the house was Alice "Alcie" Heard, a noted artist, who sold it to the Ipswich Historical Society in 1936. As a condition of the sale, she was given tenancy for the rest of her life. She died in 1953. (Ipswich Historical Society.)

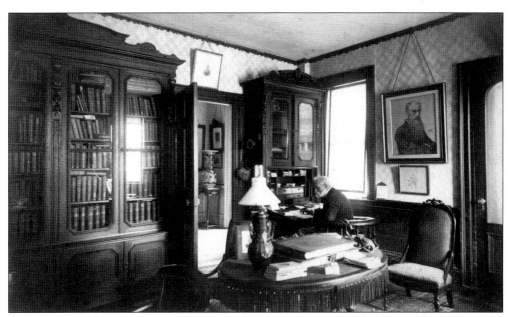

Augustine Heard was often away from Ipswich as a "supercargo" and sea captain. However, the legacy resulting from his fortune made as founder of Heard and Company, a giant in the China Trade, endures in his family mansion, the Ipswich Public Library, the financing of the local mills, and the behind-the-scenes contributions to many aspects of the town's growth and well being. Here, Heard is seen in the library of the Heard House. (Ipswich Historical Society.)

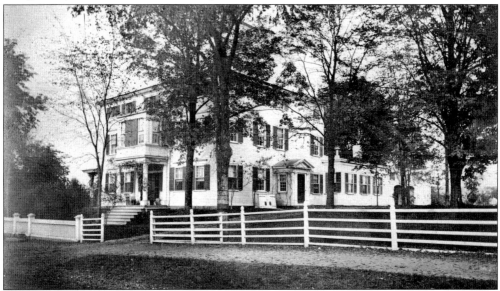

The Heard House, now the headquarters of the Ipswich Historical Society, was built by John T. Heard between 1795 and 1800. Heard was the father of 13 children, but both of his two wives had died before this house was occupied. Previously on this site was the house of Dr. Calef, a prominent resident and military physician during the French and Indian War. Calef was a Tory who fled to Canada during the Revolutionary War. His former home, built c. 1750, was moved one block away, where it remains today, at the corner of Poplar and Payne Streets. (Ipswich Historical Society.)

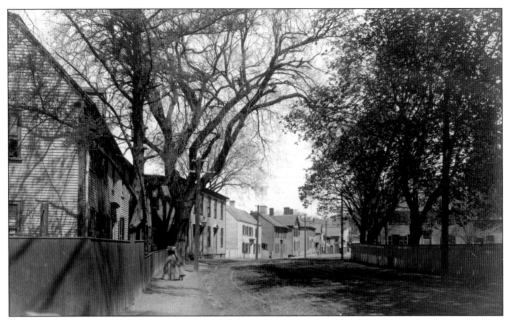

In the foreground of this view of South Main Street is the *c.* 1716 Philemon Dean House which, from 1824 to 1827, was the factory of the Boston and Ipswich Lace Company. The second house beyond that, now the headquarters of the Quebec Labrador Foundation, was Atherley's boardinghouse for mill workers. Beyond that is the Jones House, where George Whitefield stayed when in town for his great religious revival meetings in the 1740s. (Ipswich Historical Society.)

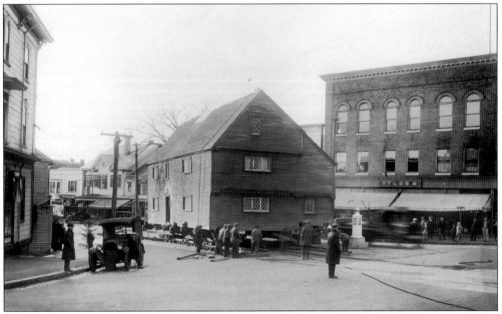

In 1927, the Whipple House was dragged through town and across the Choate Bridge to a new location beside the South Green. The move rescued the headquarters of the Ipswich Historical Society from what had become an industrial location and gave it much better visibility as Ipswich became a destination for tourists traveling on Route 1A. (Ipswich Historical Society.)

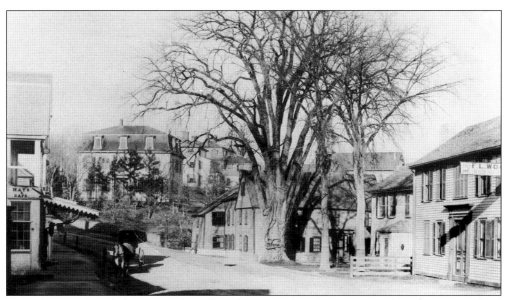

This photograph, taken just south of the Choate Bridge, shows part of downtown Ipswich in the 1880s. On the left, marked by the "Hats and Caps" sign, is Baker's Clothing store, with a second-floor open veranda. In the background, with a mansard roof, is the then recently closed Female Seminary building, the First Period Ross Tavern, and the Baker residence. The sign on the right advertises Fred Wood's blacksmith shop in the rear. With its nearby mill boardinghouses, this spot was a local hangout. According to a July 1881 newspaper account, females were often harassed here and forced to detour to the County Street Bridge. (Ipswich Historical Society.)

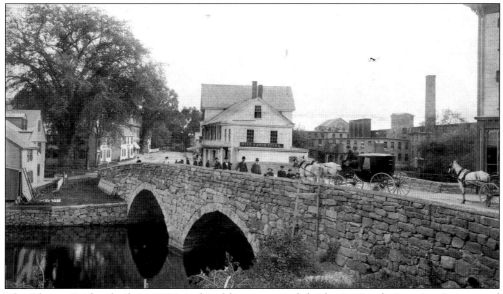

The Choate Bridge, built in 1764, is the oldest stone arch bridge in North America. It is named for local resident Col. John Choate, who supervised its construction. Legend says that Choate was on horseback ready to flee if the bridge, with its radically new method of construction, collapsed when first used. Originally only a single lane wide, the bridge was widened in 1838 and underwent major restoration in 1989. (Courtesy Bill George.)

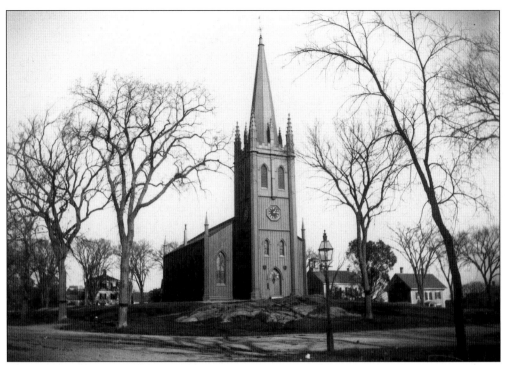

Ipswich became a town after building the First Church of Ipswich and hiring the first minister in 1634. Erected in 1847, this was the fifth building of the First Church of Ipswich to be built on the same site on the North Green. This classic New England Gothic building, at one time painted red, was destroyed when struck by lightning in June 1965. (Ipswich Historical Society.)

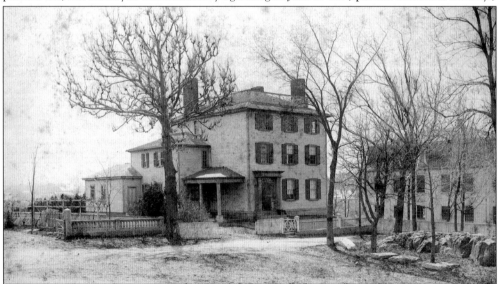

This house on the south side of Town Hill was built in 1799 by John Heard for his daughter. It was the family home of Dr. Thomas Manning, who founded the Willowdale Blanket Mill and the wind-driven woolen mill, next to the Choate Bridge. After Manning's death in 1858, the house was purchased by Augustine Heard, who gave it to the First Congregational Church for use as a parsonage. (Ipswich Historical Society.)

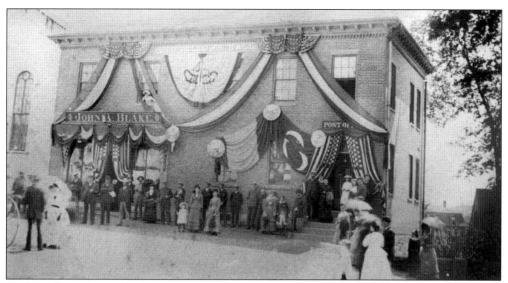

Decorated no doubt for the town's 250th anniversary in 1884, the Probate Court Building was built in 1817. The building was purchased in 1867 by the Odd Fellows, and a second story was added. In 1884, it was the Odd Fellows Hall, post office, and John Blakes's drugstore, which was advertised as "the best place to buy Trusses, Syringes and Hot Water Bags." (Courtesy Bill George.)

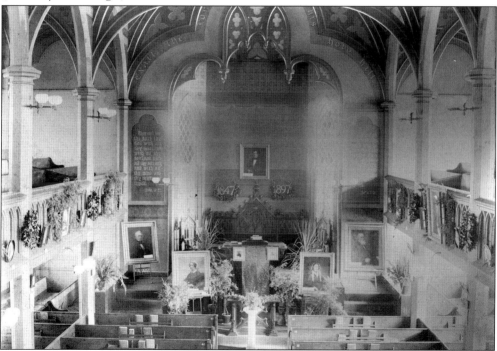

In 1897, the First Church of Ipswich celebrated the 50th anniversary of its Gothic-style building. The prominence of the Heard family as members and benefactors of its congregation is indicated by portraits of various Heard family members displayed around the altar. Many of these portraits can currently be seen hanging in the collection of the Ipswich Historical Society at the Heard House. (Ipswich Historical Society.)

This view of the north side of Meeting House Green shows the house (with a later mansard roof) built by Capt. Israel Pulsifer *c.* 1820. The First Congregational Church chapel and the Dennison School are on the far corner. (Ipswich Historical Society.)

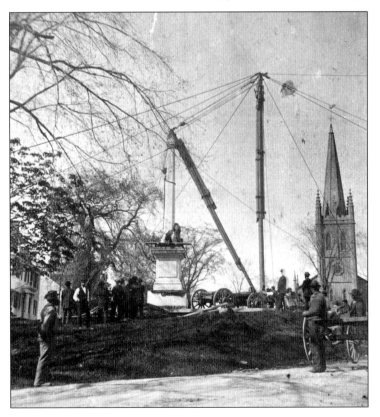

The town's Civil War Monument was dedicated on March 13, 1871. Ipswich sent some 375 men and boys to fight in the Civil War, 54 of whom did not return. To this day, Ipswich has a well-attended service to remember those and other war dead on Memorial Day at this site on Town Hill. (Ipswich Historical Society.)

This is the High Street railroad crossing as it looked before the first overpass was built in 1906. In 1881, Ipswich blacksmith Benjamin Smith was killed here when his buggy lost a race with a train. On the right is a crossing tender's house, common at all local grade crossings. Most crossing guards supplemented their railroad income by making and repairing shoes while waiting for the next train. (Ipswich Historical Society.)

To protect its passenger business, the Boston & Maine Railroad forbade trolley cars to cross its tracks. From 1900, when the first trolley cars came to town, until this overpass was built in 1906, passengers on the Georgetown, Rowley, and Ipswich Street Railway had to walk across the tracks and board a second car waiting on the other side in order to continue their journey. (Ipswich Historical Society.)

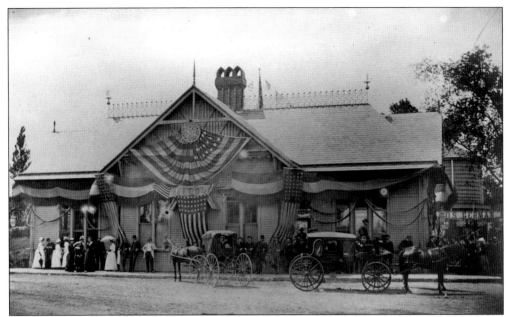

The new Ipswich railroad station, which opened in June 1882, is shown decorated for the town's 250th celebration in 1884. It is said that in proportion to its population, Ipswich had more carriages for hire than any other station on the Eastern Railroad. During the station's last years, one side of the building was used as a commercial laundry, until the whole structure was torn down in 1958. (Courtesy Peabody Essex Museum.)

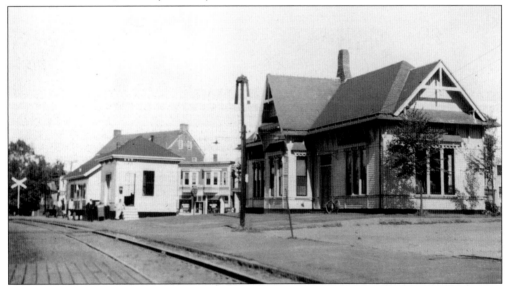

Another view shows the second railway station in Depot Square. Unfortunately, photography was too new to capture the arrival of the first train in December 1839. However, an eyewitness account of that event was published in an 1884 newspaper. Most townsfolk had gathered for the long-awaited moment of the train's arrival. When they saw the firebox patented from hell, a smokestack belching smoke and cinders, and pounding valves with escaping steam, most of them ran into the woods to hide. It was with great trepidation that they finally crept out to view the iron monster. (Ipswich Historical Society.)

30

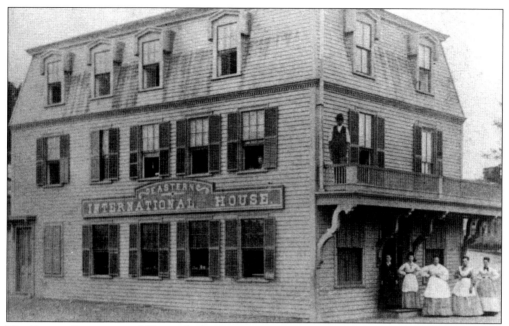

The Eastern International House, built in 1862, was located in Depot Square on the site of the current Cooperative Bank. The Eastern Railroads connected with a Maine railroad that ran to Canada, hence the term "international." Water from the Ipswich River was used to replenish the steam engines, and the passengers could have a meal at the hotel during the stopover. The hotel was moved to Central Street in 1880 to make room for the new railroad station, which opened in June 1882. (Ipswich Historical Society.)

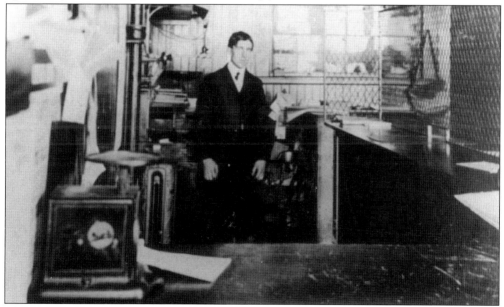

Charles R. Lord was manager of the Railway Express office at the Ipswich station for over 50 years. Ironically, after he retired and the Ipswich office was discontinued, the freight building was sold and moved to the rear of the property directly across the street from his home near Lord's Square. (Courtesy Marian Kilgour.)

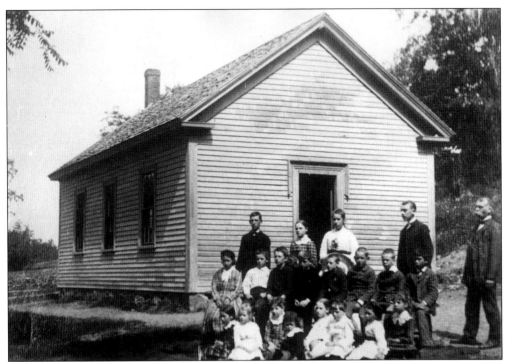

During the 19th and early 20th centuries, Ipswich had as many as eight different neighborhood schools. This is an 1887 photograph of the Linebrook School, which closed in 1936. The building was sold to Charlie Henley and was moved downtown to Central Street, where it was used as a secondhand shop and garage. It is said that the old blackboards are still on the walls. (Ipswich Historical Society.)

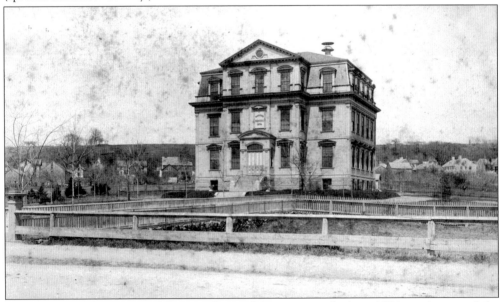

The Manning School, named for Dr. Thomas Manning, was built in 1874 on the site of the current Winthrop School. It served the students of Ipswich until the recently closed Whipple Middle School was opened in 1937 as Ipswich High School. (Ipswich Historical Society.)

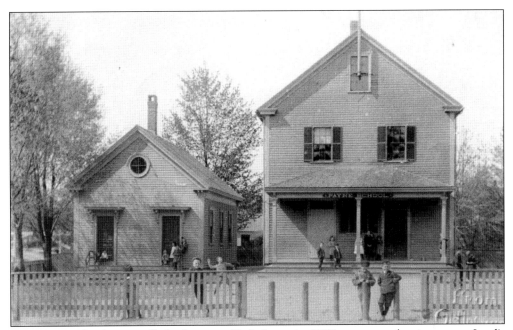

The Payne School, originally built nearer High Street in 1802, was moved to its current Lord's Square location in 1891. The smaller school on the left had been the Ipswich Village School, near the Rowley town line. That building is now a cemetery storage building at the Town Farm Road entrance to the cemetery. (Courtesy Bill George.)

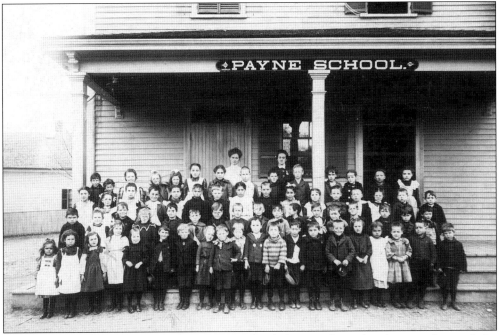

What could be more picturesquely New England than students lined up in front of the village school for their annual picture. The Payne School in Lord's Square was last used for students in 1942. In 1972, it was renovated for use as school department offices. (Ipswich Historical Society.)

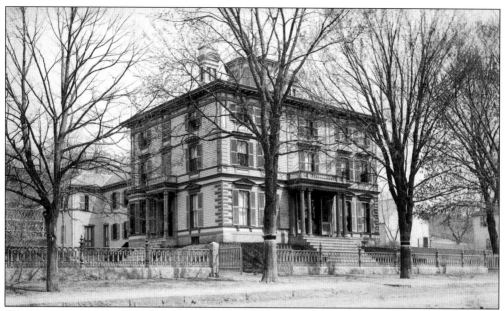

The Ross Mansion on High Street was another property of the ever-industrious Dr. John Manning. From 1827 to 1832, this residence became the factory of the New England Lace Company. It was later renovated as the home of bridge builder Joseph Ross and was torn down c. 1930. (Ipswich Historical Society.)

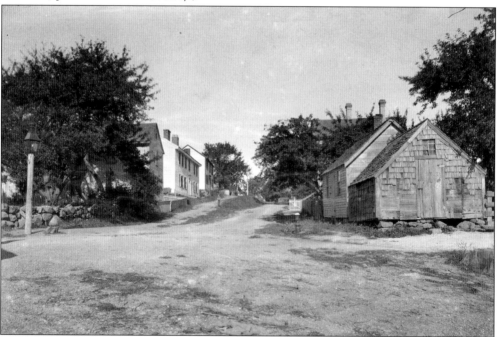

Summer Street, at one time called Annable's Lane, is said to be the oldest "way" in Ipswich. At one time there was a hay scale located here at the lower end. Hay was the primary cash crop of the local farmers in the 19th century, as Ipswich hay was preferred to feed the horses pulling the cars of the Boston Street Railway. Caravans of hay wagons are said to have been a common sight on the Newburyport Turnpike between Ipswich and Boston. (Ipswich Historical Society.)

This winter scene of the Female Seminary was taken after it closed in 1876. The building later had a number of commercial tenants, including the photographer George Dexter after he was burned out of his Central Street studio in 1894. It was torn down in 1932 and is now the site of the Christian Science Church. (Courtesy of Bill George.)

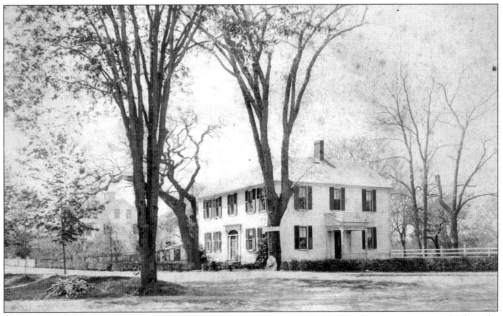

The Wally-Dana House, named for the first two ministers of the South Congregational Church, was located on what is now the Whipple House lawn. Rev. Joseph Dana was responsible for the documentation of the Ipswich lace industry between 1790 and 1791. His account of Ipswich lace production is now in the Library of Congress. This house was torn down in 1958. (Ipswich Historical Society.)

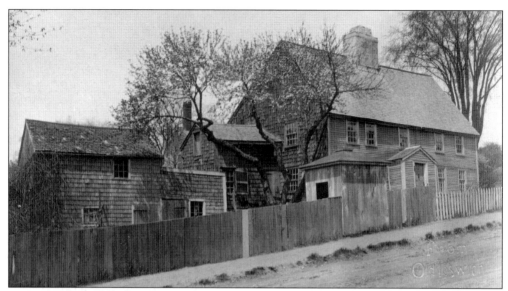

This view shows the Caleb Lord House, previously called the Harris House, as it appeared after Manning Street was cut through the former orchard in its front yard in 1882. This building had been the town almshouse before the poor farm was built on Town Farm Road in 1838. (Courtesy Bill George.)

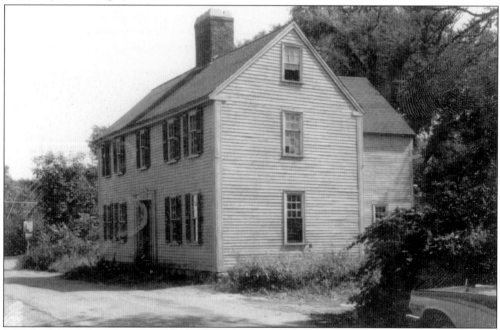

This house, built *c.* 1768 by Abraham Choate, is the so-called "other Hart House" that once stood on Elm Street. It was known as the Hart House because of the *c.* 1710 rear ell built on a nearby lot by George Hart and attached to Choate's new house. In 1963, two local women saved it from destruction when they challenged the wrecking crew on the morning it was scheduled for demolition. The frame was moved to Washington, D.C., where it is now part of a major exhibit at the Smithsonian Institution. (Courtesy National Museum of American History, Smithsonian Institution.)

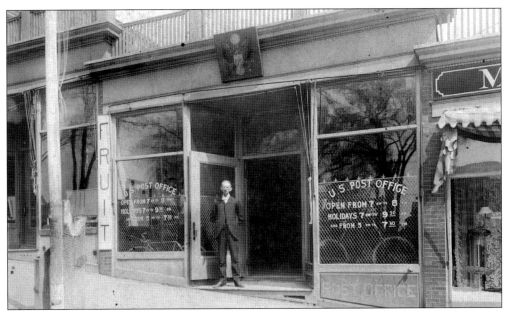

Luther Wait was certainly a small-town success story. He is shown in the doorway of the post office, when it was in the Jones Block, currently the site of the Christian Science Church. Completing his formal education at age 12, he served in both the army and navy during the Civil War, fished off the Grand Banks during the summer, and stayed home to make shoes during the winter. Also participating in the Klondike Gold Rush, he served on many town committees, including the school board, and was postmaster from 1890 to 1894 and from 1902 to 1914. (Ipswich Historical Society.)

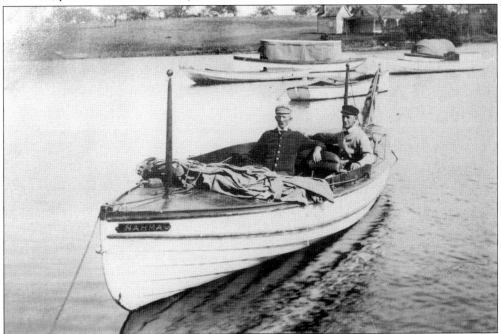

Postmaster Luther Wait is shown in the boat he used to deliver mail downriver to the Neck and Plum Island. (Courtesy Bill George.)

This building, opened in 1892 at the corner of Elm and South Main Streets, was the new office of the Ipswich Savings Bank. Originally incorporated in 1869, the bank previously conducted its business in the paint store of its treasurer Theodore Cogswell, which had occupied the same site. In 1913, the bank moved to its current location on Market Street. (Courtesy Bill George.)

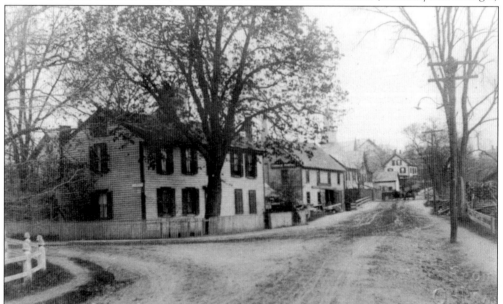

This early-1900s scene, looking toward the County Street Bridge, shows County Street at the corner of Elm Street. The now-restored Benjamin Grant House, built in 1735, is in the foreground, but the Dunnels House has not yet been moved from South Main Street to replace Spiller's carriage shop, rebuilt after the 1879 fire. The Ipswich Woolen Mill is seen on the opposite side of the bridge. (Courtesy Bill George.)

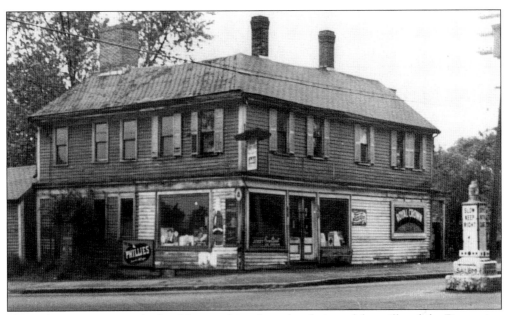

Shown here to represent the hardship resulting from the closing of the mill and the Depression is the store at Lord's Square, formerly owned by Nat Burnham, captain of the *Carlotta*. When the mill closed, throwing 1,200 of the town's 2,600 employed out of work, Ipswich was described as "a blue collar mill town without a mill." The traffic island is said to have been hit more often than a prizefighter. This site later became home to a Sunoco Station, followed by a Richdale store, followed by a Dunkin' Donuts. (Ipswich Historical Society.)

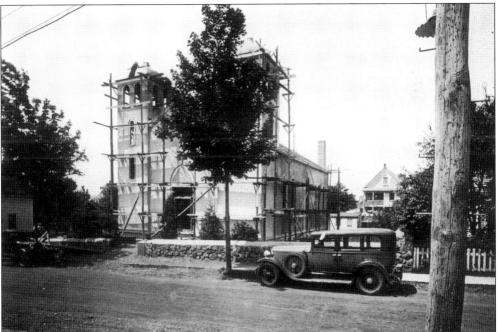

The first Greek church in Ipswich was built on Lafayette Road in 1907. It burned in 1930. The present Ascension of the Virgin Mary (Greek Orthodox) Church is shown nearing the end of construction in 1934. (Courtesy Jane Bokron.)

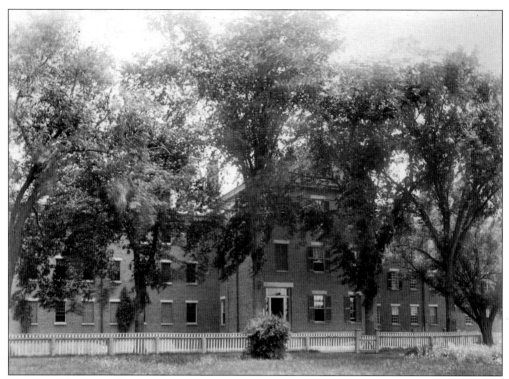

The Ipswich County Jail, built in 1828, was next to the river on a Green Street site recently occupied by the Whipple Middle School. Housing both men and women, the building had one wing that was used as the jail and another used as the lunatic asylum. Often described as a well-run, humane institution, it closed c. 1930 and was torn down in 1933 as a Works Progress Administration (WPA) project for the local unemployed. (Ipswich Historical Society.)

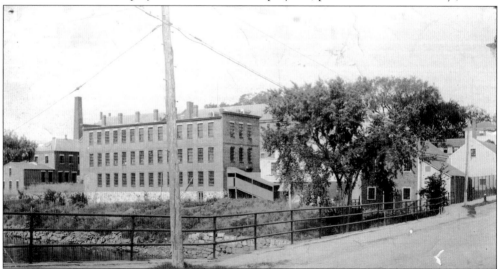

This view from the Green Street Bridge shows the still-standing shoe shop in back of the Ipswich County Jail. Although most of the buildings are now gone, until recently the three-story former prison workshop was the annex of the Ipswich Middle School. (Ipswich Historical Society.)

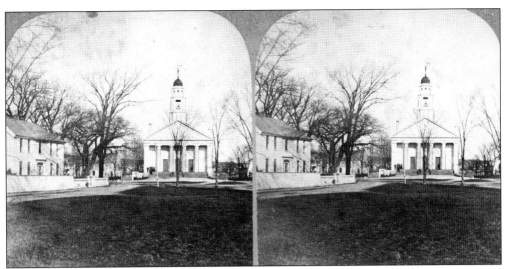

For over 100 years, the 1838 South Church presented a classical entrance to the south side of town. At the time this picture was taken, historian Thomas Franklin Waters was the new minister of this church and the Wally-Dana House on the left was the church parsonage. At the Heard House, the barn (to the left of the church) that burned in May 1879, victim of a series of incendiary fires, can be seen through the trees. (Ipswich Historical Society.)

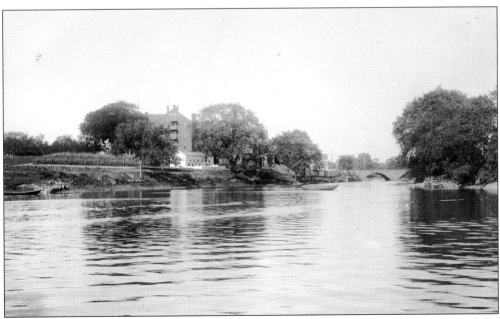

This view of the river *c.* 1920 was taken from just below the lower falls, looking toward the Green Street Bridge. The Ipswich County Jail is on the left. Formerly called the Great Cove, this was the scene of shipbuilding, warehouses, the Heard distillery, and great commercial activity until the early 1800s. (Ipswich Historical Society.)

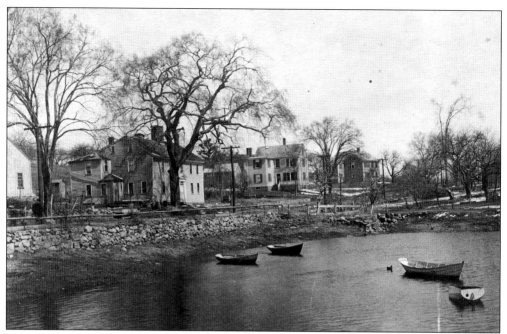

These houses were located across from the town wharf during its waning years of commercial importance. Shown, from left to right, are mariner Richard Lakeman's home and two Hodgkins residences. (Ipswich Historical Society.)

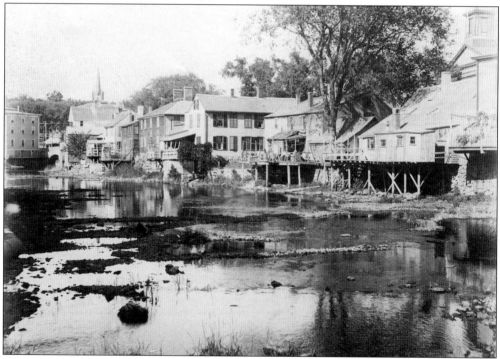

This *c.* 1900 scene of the back of the buildings on the west side of South Main Street, mostly unchanged today, has been the subject of many postcards titled "Little Venice." (Ipswich Historical Society.)

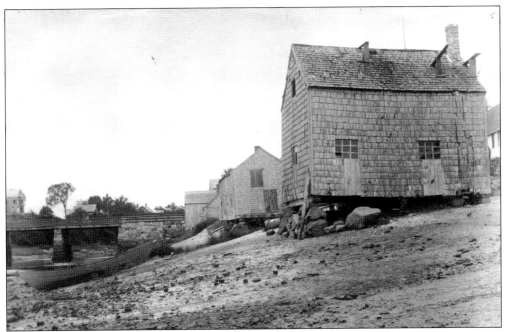

This classic Arthur Wesley Dow photograph of the Water Street clam shanties also shows the Green Street Bridge. The bridge was constructed in 1881 and was replaced by the recently restored bridge in 1894. (Ipswich Historical Society.)

This was the home of Tristram, Fred, and George Fall, on East Street. The Falls were one of a half dozen families who had come from Ossipee, New Hampshire, with Jacob Brown in the early 19th century. At one time Tristram Fall was the police chief. George Fall was a coal and lumber dealer, and Fred Fall collected milk from Ipswich farmers for the local creamery. (Ipswich Historical Society.)

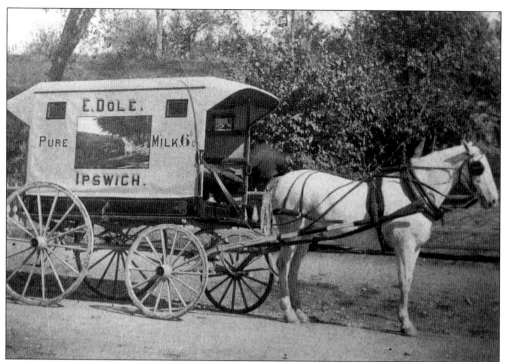

Like most New England towns, Ipswich had home delivery of many products, including groceries, milk, and ice. This is the milk wagon of Edward Dole, whose farm was located north of the railroad overpass on High Street in the area where the White Cap Restaurant is today. (Ipswich Historical Society.)

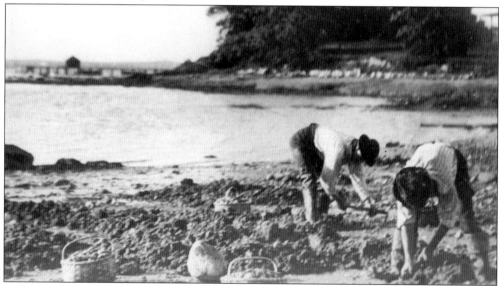

Clams have always been available for the Ipswich diet, but before the advent of the first fried clams, a speaker at the town's 250th celebration described them as a food of last resort. During the Depression, with half the town unemployed, the license fee was waived, but almost immediately there was a new crisis when the clam beds were all but dug clean. (Courtesy Bill George.)

Shown here is the house and barn of the 132-acre Bull Brook Farm on Linebrook Road. During Prohibition, prior to the Galicki purchase in 1929, the farm was raided a number of times for having one of the biggest stills in the area. Anton Galicki raised pigs and chickens, and had a dairy herd and local milk route during the 1930s. (Courtesy Fran Galicki Richards.)

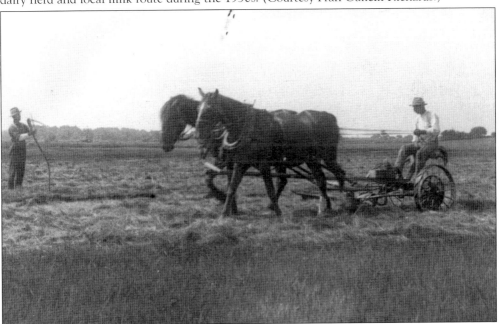

As in most New England communities, many Ipswich men were farmers to some degree. In the 1870 federal census, more than half the families of Ipswich listed their occupation as farmer. The great majority had a garden, cut hay for their animals, and remained slaves to the soil until the day they could no longer work. (Ipswich Historical Society.)

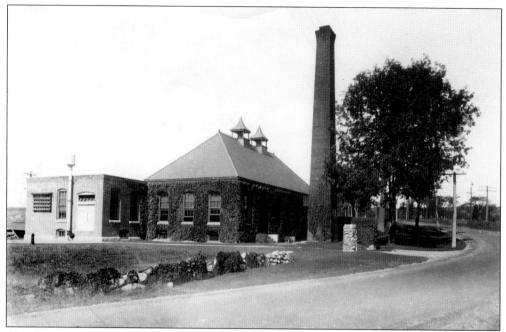

This building commemorates the legacy of *Ipswich Chronicle* editor George Schofield, who fought for years for municipal improvements. The town water system was constructed in 1894, and the pumping station, built in 1903, is still the home of the Ipswich Municipal Electric generating plant. (Ipswich Historical Society.)

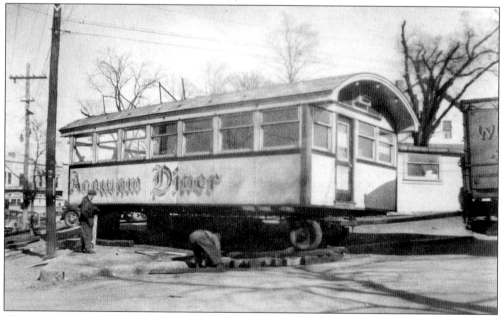

This is the first of four different Agawam Diners that did business across from the railroad station on the corner of Salstonstall Street. Shown here, it is being prepared to be moved to Brunswick, Maine. It was later returned to the current Agawam Diner site in Rowley, before being moved to the north side of the Merrimack River Bridge in Newburyport. (Courtesy Wilbur Trask.)

# Three

# TO EARN THEIR
# DAILY BREAD

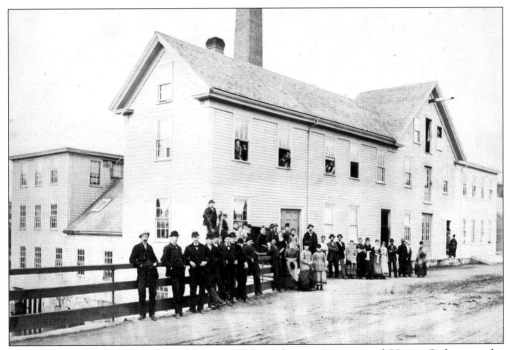

The Ipswich Woolen Mill was built in 1863 by Sylvanus Canney and Henry Ordway at the northwest corner of the County Street Bridge. This hosiery knitting mill was said to be very successful until it lost much of its uninsured, warehoused stock and business as a result of the Great Boston Fire of 1872. The Ipswich building was then used as a box factory, which was referred to as a firetrap, until it had a fire in 1895. At that time Canney moved his box factory to the current site of Tedford's, in Brown Square. Ipswich Mills then used this building as a warehouse until it was torn down c. 1920. (Ipswich Historical Society.)

This picture of the Stackpole and Sons Soap Factory, on the current site of Giles Firman Park on County Road, obviously was taken after 1900. For many years this was the site of Farley's Tannery, the soap and fertilizer business advertised as dealing in all parts of the discarded carcass, including hair, bones, hides, tallow, and grease. (Ipswich Historical Society.)

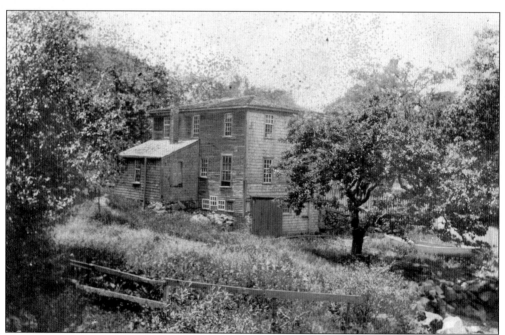

This house, located on Turkey Shore Road near the corner of Poplar Street, was the hand-frame knitting mill of John Birch. John Birch was one of the original knitting pioneers who came from England before the introduction of power looms. The house was no longer on the site in 1924. (Ipswich Historical Society.)

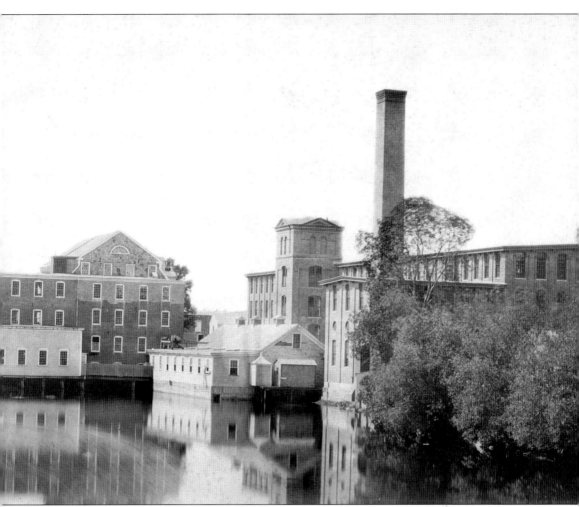

Ipswich began its textile production as a cottage industry on hand frames, but with the 1828 erection of the stone mill with the gable end, seen in the center of this picture, it joined the Industrial Revolution. From that time these buildings have been the centerpiece of the town's industry. After a number of unsuccessful attempts to manufacture cotton cloth, in 1867 the mill was purchased by Amos Lawrence of Merrimack River prominence, and Ipswich became the hosiery capital of the country. At its most productive, Ipswich Mills employed over 2,600—in waves of Irish, French Canadian, Polish, and Greek immigrants—and its real estate included a large neighborhood of employee housing. At one time it also had branch mills in South Boston, Gloucester, Lowell, and Belmont, New Hampshire. However, as women's skirts got shorter, Ipswich Mills's shapeless baggy product did not match its logo of an attractive long-legged witch on a broomstick, and failing to modernize, the company was forced out of business in 1928. (Ipswich Historical Society.)

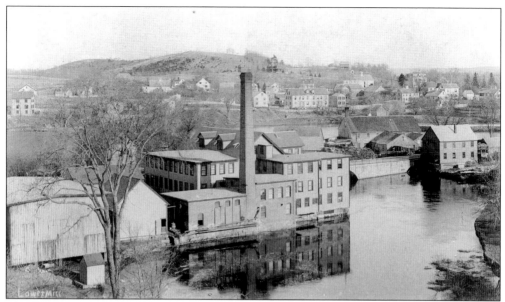

This busy industrial complex of at least six different businesses was located on County Street where the County Street Bridge crosses Falls Island. This view, taken before 1879 when the buildings on the right burned, shows the back of the Ipswich Woolen Mill in the foreground, Damon's Sawmill in the center on the opposite side of the bridge, the two-story Chapman's carriage works building on the right, and Heartbreak Hill in the background. (Ipswich Historical Society.)

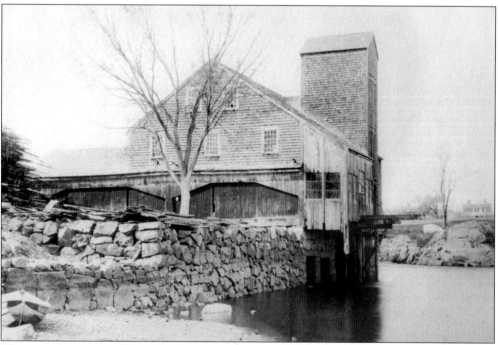

This very large sawmill was built in 1870 by Fred Damon over the natural sluiceway at Falls Island. It experienced several small fires in the 1880s and was finally torn down. (Courtesy Bill George.)

These buildings, located on County Street between Elm Street and the County Street Bridge, were part of the Damon Mills complex on Falls Island. They were destroyed in a spectacular fire, thought to have been arson, on April 26, 1879. Among the businesses destroyed were the three-story wheelwright and paint shop of Charles Chapman, the wheelwright shop of William Spiller, and a blacksmith shop and barn of James Damon. A dozen wagons and carriages being repainted in the shop of Warren Boynton were also destroyed. (Ipswich Historical Society.)

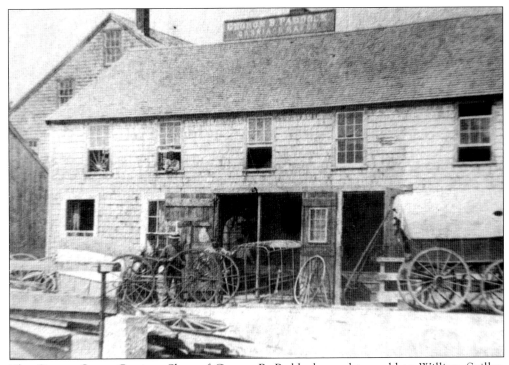

The County Street Carriage Shop of George B. Paddock was later sold to William Spiller. (Ipswich Historical Society.)

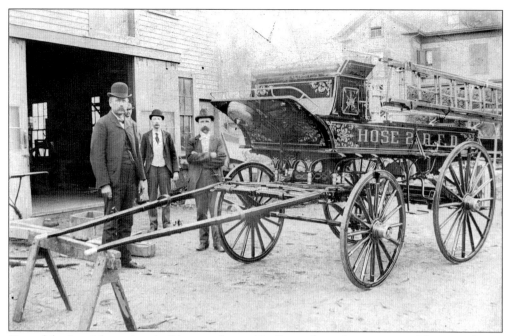

One of the Ipswich carriage builders was James Graffum, whose factory was on Hammatt Street in a building currently occupied by Agawam Auto and Hardware. Shown here in 1901, with a custom-made hose wagon for the Rockport Fire Department, are James Graffum, Charles Graffum, and wheelwright Charlie Dodge. Blacksmith Joseph King is standing in the doorway. Graffum's carriage painter was Joseph Malenfant. (Ipswich Historical Society.)

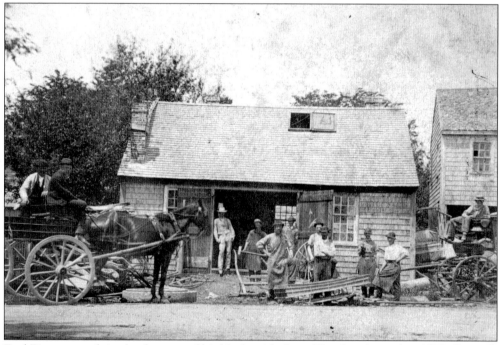

Fred Damon stands in the doorway of his blacksmith shop. The shop burned in 1879. (Ipswich Historical Society.)

This diminutive factory was the Perkins and Daniels shoe shop located just south of the Dennis-Dodge house on lower Summer Street. It burned in April 1888. Pictured, from left to right, are Moses Saunders, Rufus Knox, James Webber Jr., and James Webber Sr. (Ipswich Historical Society.)

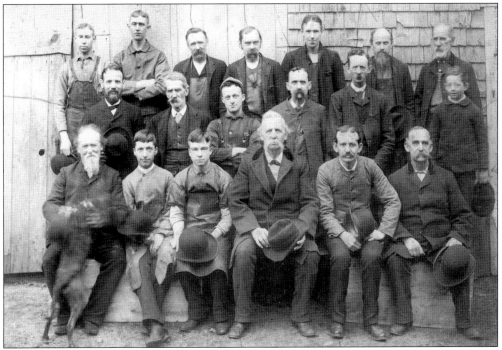

These are the faces of the Farley and Daniels shoe shop, which operated on Market Street. This picture was taken c. 1886. Pictured, from left to right, are the following: (front row) William Walton, Howard Jewett, John Quill, Richard Daniels, Lyman Daniels, and William Nichols; (middle row) Charles Noyes, Moses Webber, George Spiller, Albert Nichols, Luther Wait, and Charles Falls; (back row) Charles Kimball, Henry Stevens, two unidentified people, Moses Sanders, Dexter McIntyre, and James Webber. (Ipswich Historical Society.)

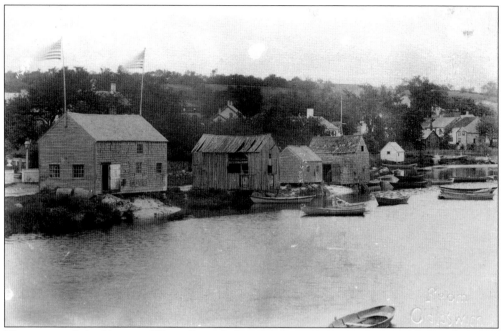

These riverside buildings on Water Street below the Green Street Bridge are the so-called clam shanties, where the locals kept their gear and shucked their harvest. The shanties were often the subject of the town's artist community, but none survive. (Ipswich Historical Society.)

This is the gristmill (later, a coal barn) built by George B. Brown on what was to become Brown Street. Note the covered railroad siding built to accommodate carloads of grain. This mill burned in a spectacular fire on March 11, 1976. (Courtesy Wilbur Trask.)

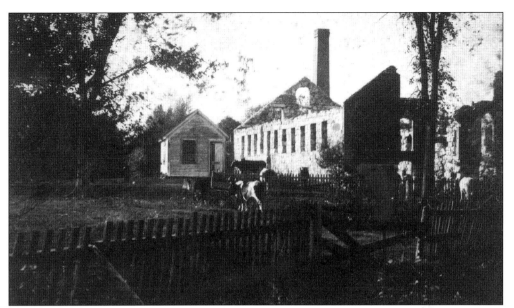

The first stone Willowdale Mill was built c. 1834, at what is now Foote's Dam, by Dr. Thomas Manning. Called Manning's Mill, the complex was on both the Hamilton and Ipswich sides of the river. During the Civil War, this mill made 55,000 pairs of stockings for the Union Army in the year 1864 alone. Converted to a blanket mill, it burned in April 1881. Rebuilt, the mill suffered another fire, in 1884. That fire, which was in the attic storeroom, burned or ruined the inventory of 700 blankets, and the mill stopped production and never reopened. (Ipswich Historical Society.)

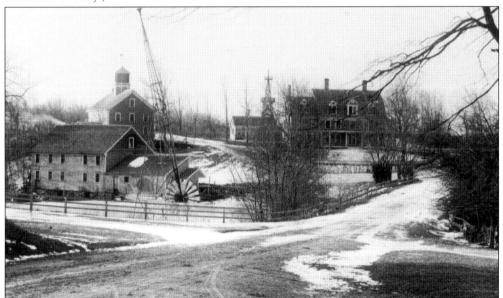

The Norwood Mills were built in 1857 on both sides of the Ipswich River by Dr. Thomas Manning and Caleb Norwood. On the south side were a sawmill, gristmill, and cider mill. On the north side, the mill made isinglass from fish bladders. Isinglass as a gelatin was used in making beer and glue. The house on the far side of the river has been moved to the opposite side of Mill Road. (Courtesy The Trustees of Reservations.)

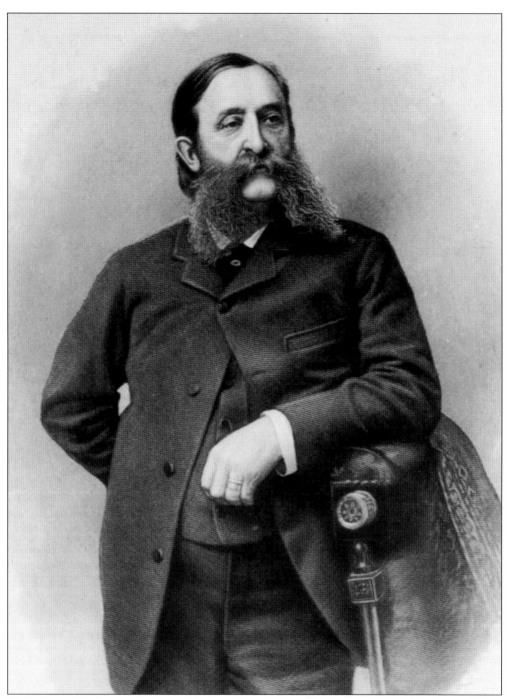

One of the town's most important businessmen was William Gray Brown. Former employees are said to have filled half the church at his funeral in 1894. His business experience began in 1838 as a small boy, peddling a basket of pastries made by his mother to the men building the railroad. He later owned Brown's coal wharf and coal schooners, and the local brickyard. At one time he owned the Agawam Hotel and Livery Stable, as well as a livery stable opposite his home on Topsfield Road. (Courtesy Ipswich Public Library.)

# WOOD  COAL

— AND —

## LIME, SAND & CEMENT

Constantly on hand and of the best grades produced. Also

## LIVERY AND HACK STABLE,

## REAR OF AGAWAM HOUSE.

All orders left at the office of the Agawam Stable and at my residence will be promptly attended to.

## WM. G. BROWN.

If a local business required draft animals to conduct its daily activities, William G. Brown no doubt owned the business and the beasts of burden, and employed the men to drive them. (Ipswich Historical Society.)

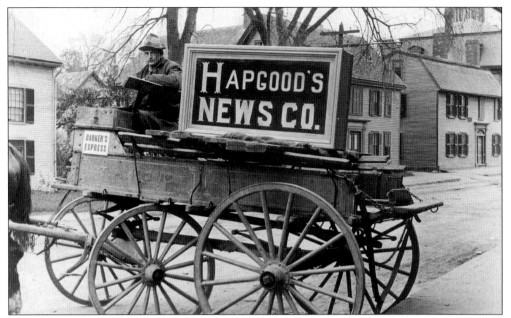

Baker's Express wagon is parked on the west side South Main Street in front of Baker's Clothing Store, with what appears to be a new sign for Hapgood's News Store, which was located in the Opera House building (later, the Strand Theater). To the right of the photograph are several early houses, now destroyed or moved, and the Ipswich Town Hall. (Ipswich Historical Society.)

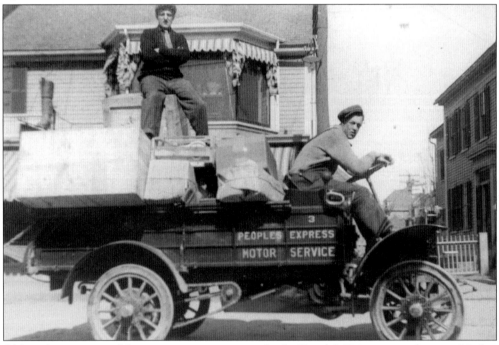

Although not as graceful as a wagon or a stagecoach, the People's Express, seen here on Market Street, proves that Ipswich had moved into the machine age. The Jewett House is on the right. Al Wait is in the driver's seat, and George Byron is riding shotgun. (Courtesy Bill George.)

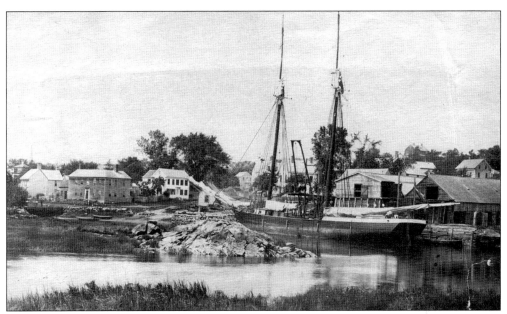

A coal schooner is unloading at Brown's Wharf, recognizable as today's town wharf. The local anthracite coal business was begun by Jacob Brown, who came to Ipswich from Ossipee, New Hampshire, as a teamster of oxen before the coming of the railroad. (Ipswich Historical Society.)

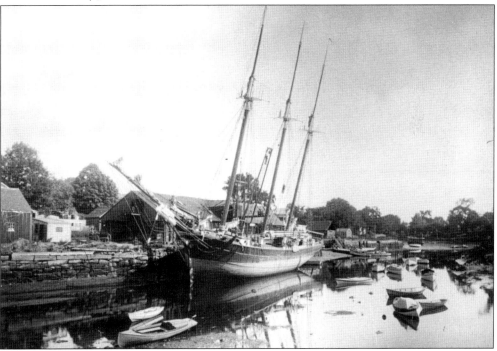

This is apparently one of the last large ships to unload at the town wharf. The channel had become narrow, and ships had to be guided around the corner at Ring Bolt Rock with hawsers. At low tide boats often keeled over and, in one incident, a boat destroyed a portion of the wharf. (Ipswich Historical Society.)

This 1909 view from a Market Street rooftop looking toward Brown's Square shows the Gas Company, founded in 1877, in the foreground. Behind it, on Hammatt Street, are buildings built by the Lincoln Manufacturing Company. Canney's Lumberyard is on the left, and Burke's Heel Factory is in the background. (Ipswich Historical Society.)

At the time of his death in 1938, Ralph W. Burnham is said to have been one of the town's most outstanding businessmen. Primarily an antiques dealer, he operated Burnham's Trading Post and was responsible for restoring the 1640 Hart House and turning it into an inn. In the very early 1900s, he and his wife were the live-in caretakers of the Whipple House Museum. (Ipswich Historical Society.)

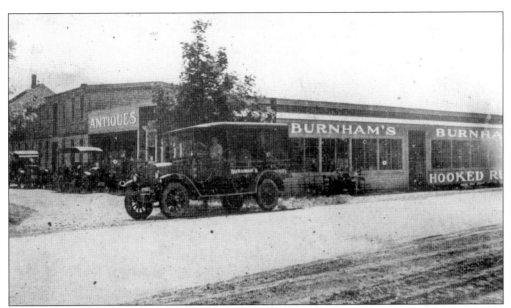

Burnham's Trading Post was originally located in a building still standing on High Street between Kimball Avenue and the new Ipswich High School. Mrs. Burnham is said to have had an antique shop at one time in the Shoreborne-Wilson House, near the Choate Bridge. (Courtesy Bill George.)

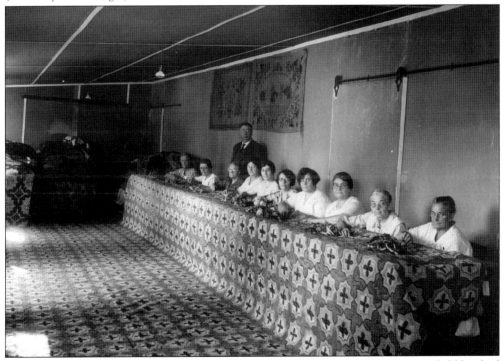

Another of the antiques-related activities of Ralph Burnham was the promotion of old hooked rugs. Originally recruited to repair antique hooked rugs, many Ipswich women later worked on the second floor of the Trading Post making new hand-hooked rugs, such as the one shown here. (Ipswich Historical Society.)

This building on Beach Road (later, Argilla Road) was the first school built by the Feoffees of the Grammar School, an organization entrusted to use the income derived from rentals on Little Neck to benefit public education. By the time this picture was taken, the new Manning High School had been built, and this building was used as a garage by the Lathrop Brothers, dealers in ice and heavy teaming. (Ipswich Historical Society.)

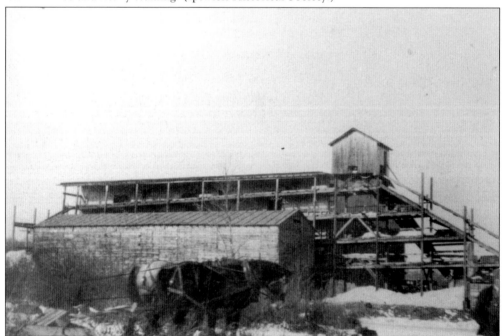

The Lathrop Brothers' icehouse was located on the river, just south of the end of Estes Street. Here, ice was stored packed in sawdust until sold during summers, before the invention of electric refrigerators. The inclines at the right were used to drag the ice into and out of the upper stories. (Courtesy Bill George.)

From its earliest days, the town felt a moral responsibility to care for the unfortunate, although it often went to great lengths to prevent indigents from moving here. For nearly 100 years, from 1838 to 1928, this well-maintained set of buildings was the town farm. Depending on age and physical ability, it was often a fine line as to whether unfortunates would be placed here, in the county jail, or in the lunatic asylum. (Courtesy Bill George.)

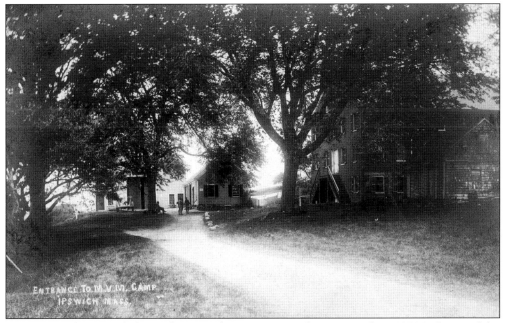

This peaceful farmyard shows the Ipswich Town Farm when it was the M.V.M. Camp of the Massachusetts Volunteer Militia. (Ipswich Historical Society.)

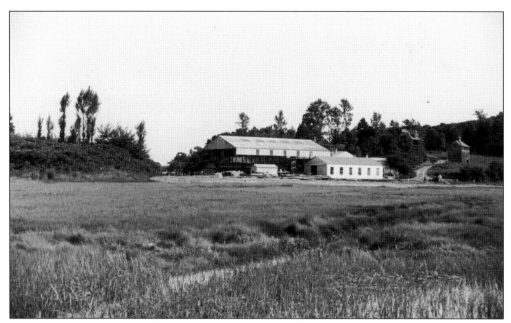

For a number of years, at the time of World War II, Ipswich had a major renaissance of boat building. Robinson's Shipyard, on Fox Creek, was owned by William Robinson, first husband of Florence Crane of Castle Hill. Its first boat, launched in 1938, was Robinson's personal craft, the *Swift of Ipswich*. Under a U.S. government contract, approximately 100 wooden minesweepers were built for the war effort. The shipyard was razed at the end of the war. (Ipswich Historical Society.)

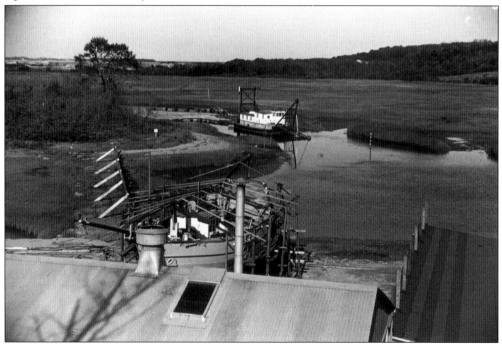

Shown is Robinson's Shipyard at Fox Creek, with a dredge deepening the channel. (Ipswich Historical Society.)

# *Four*

# BEFORE SHOPPING CENTERS AND MALLS

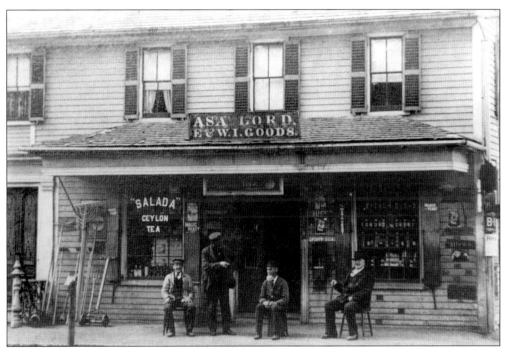

Asa Lord's store in Lord's Square was begun in 1825 with $200 worth of merchandise purchased on credit. Typical of the Ipswich grocery stores of its day, it also sold hardware, woodenware, and rubber boots. The E & W I Goods—East and West India Goods—on the sign indicates that it also sold spices and rum. In addition to operating a large delivery wagon, the store was a town social center, featuring an ongoing oral newspaper. It operated into the 20th century, when the building was split and moved to East Street and Mt. Pleasant Avenue. (Courtesy Bill George.)

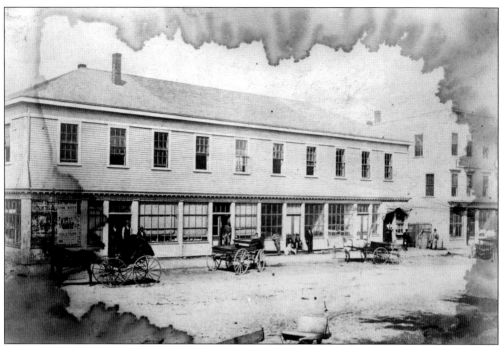

This is the first of three different Damon Buildings in Depot Square. Built as the courthouse, next to the North Green, it was moved here in 1860. In addition to Curtis Damon's housewares emporium and the site of a grocery store and barbershop, its second-floor social hall was the local roller-skating rink. This building burned in 1894. (Ipswich Historical Society.)

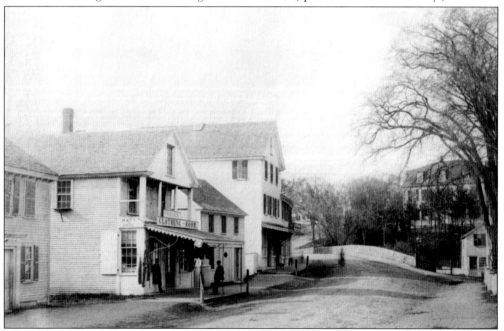

With its second-floor open veranda, this grand little emporium located at the south end of Choate Bridge was Baker's Clothing Rooms. The building between it and the bridge is Newman's Block, a housewares store. (Courtesy Bill George.)

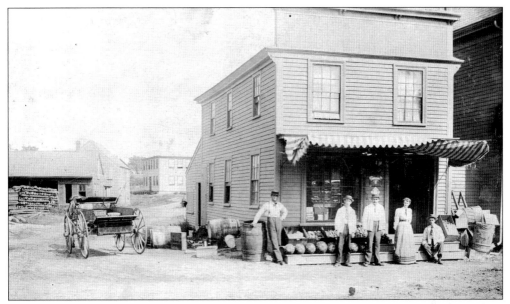

Typical of the town's grocery stores was Tozer's on Hammatt Street. Tozer, formerly a clerk for Curtis Damon, opened this store in a building owned by Mr. Broderick to take the place of those burned out when the first Damon block was destroyed in 1894. (Ipswich Historical Society.)

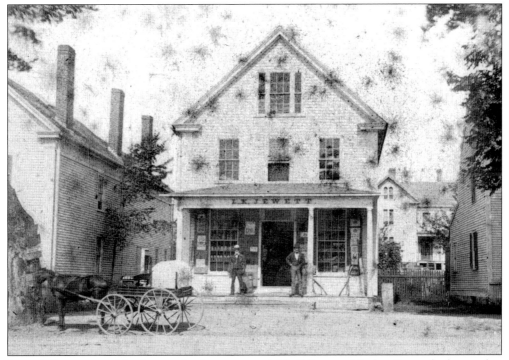

Jewett's Store, one of the longest-lasting commercial buildings on Market Street, had a number of occupants over a period of almost 100 years. In 1894, it was occupied by Plouff's Hardware Store and, in 1927, when the Whipple House was moved by its door, it had a false front on the third floor and housed the Ipswich Spa, an ice-cream parlor. (Ipswich Historical Society.)

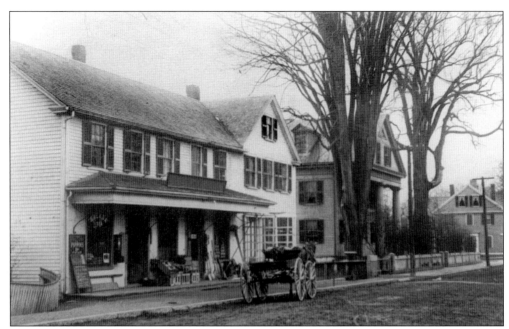

The South Side Store at the South Green was originally operated by Frank T. Goodhue, selling groceries, hardware, and crockery. The hardware business moved downtown to Market Street, but the grocery store remained as a neighborhood store. Later owned by the Riley family, it was last operated by Harold Greenhalge, who closed it in 1980. (Courtesy Bill George.)

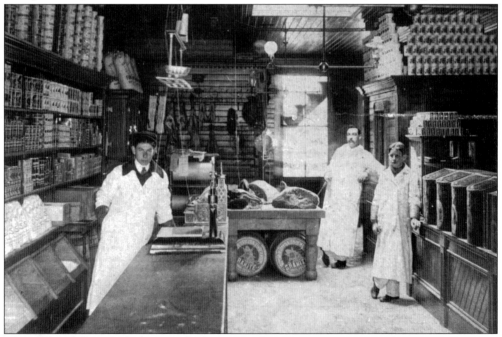

This is the well-stocked interior of Albert P. Hill's grocery store on North Main Street. First opened in 1850, it was operated by Mrs. Hill when her husband and son were away fighting the Civil War. The men pictured are said to be Walter Poole, who purchased the store in 1915, and Fred Rust, the clerk at the counter. (Ipswich Historical Society.)

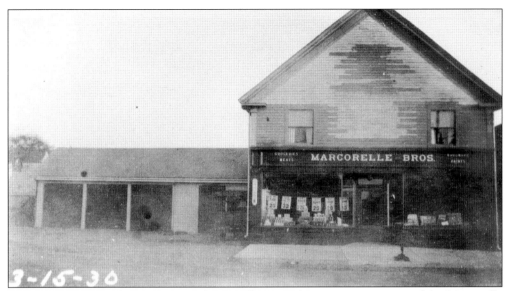

From the 1930s to the 1950s, French Canadian merchants were represented by Marcorelle Brothers in Lord's Square. This building, slightly modified but still standing, was originally Asa Lord's barn. In addition to operating the Lord's Square store, Ed Marcorelle operated the grocery store at Little Neck during the summer months. (Courtesy Elma Quill.)

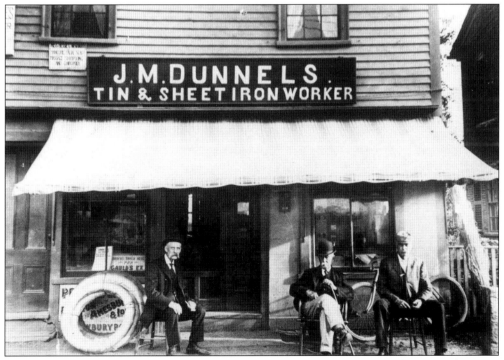

John M. Dunnels, tin and sheet metal worker, was the proprietor of this Market Street business, which dealt primarily in stoves and furnaces. (Courtesy Bill George.)

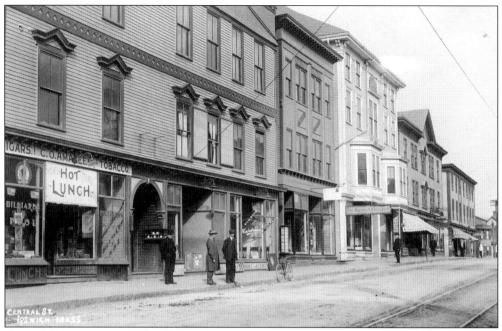

Central Street was promptly rebuilt after the spectacular fire of 1894. From left to right are Amazeen's Cigar Store in the rebuilt Amazeen Building, the Baker Building, Wilde's Block, the Measures Block, and the Red Men's Building. (Ipswich Historical Society.)

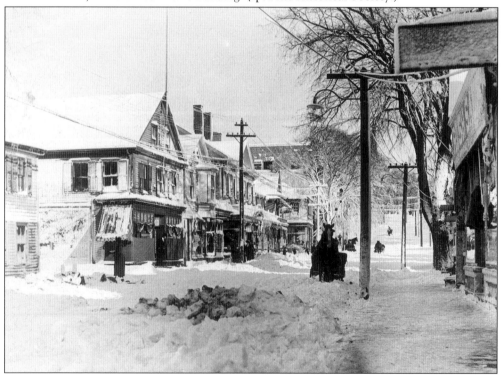

Shown in this view, looking toward Town Hill, is Market Street, glazed in ice. (Ipswich Historical Society.)

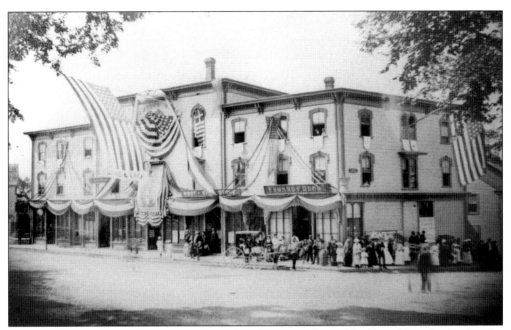

This centerpiece of downtown architectural ambiance is the Caldwell Building, built after the Coburn Building burned on October 27, 1868. It is decorated for the town's 250th celebration, in 1884. A major renovation in 1980 restored the façade to its Civil War-era elegance. (Courtesy Bill George.)

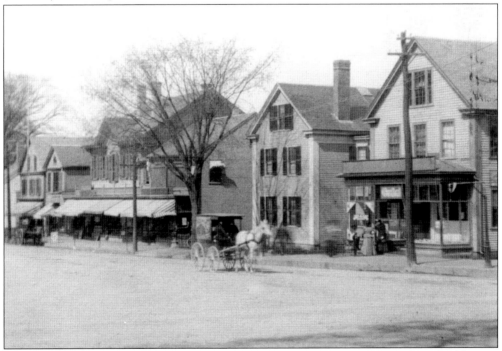

There are no parking problems in this peaceful scene on Market Street. The large building on the left is Peabody's Clothing Store, later the site of Hill's Clothing Store. On the right is the Jewett House and Jewett's Store. (Courtesy Bill George.)

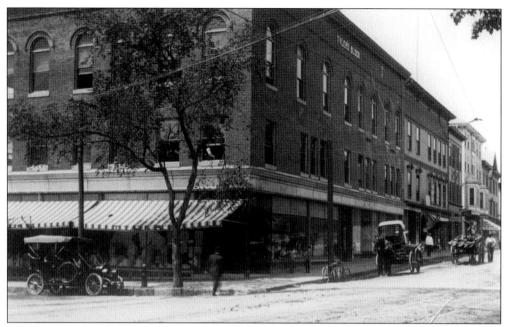

For 13 years after the Central Street fire of 1894, the lot at the corner of Central and Market Streets remained empty. Finally, Charles Sumner Tyler and his wife, Louisa, built the Tyler Block. The block combined the dry goods store operated by Louisa Tyler with Charles Sumner Tyler's jewelry store as Tyler's Department Store. The second floor housed professional offices and the local telephone company, and the third floor was the Masonic Temple. (Courtesy Bill George.)

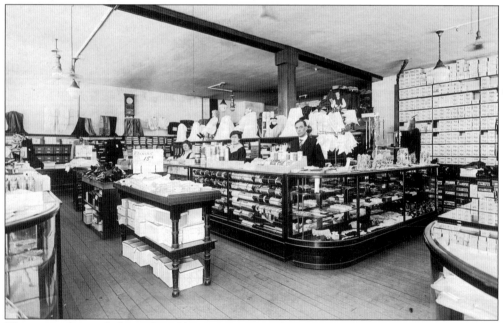

This scene shows clerks at the ribbon counter at Tyler's Department Store. There was also a bargain store in the basement. The office was on the elevated platform in the rear, enabling constant observation of most of the store activity. (Ipswich Historical Society.)

*Five*

# TRIAL BY FIRE

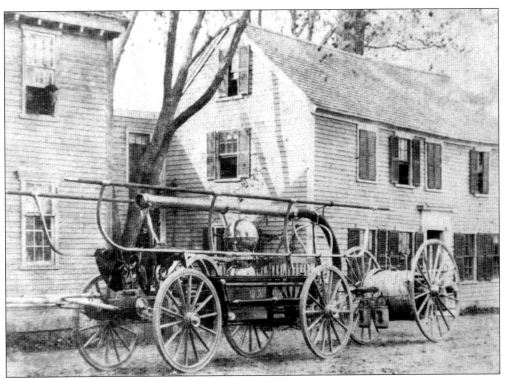

From the early 1800s, Ipswich had a number of volunteer fire companies. Shown here is the hand-pulled and hand-pumped Warren, with its independent hose reel, purchased secondhand from the town of Roxbury in 1864. (Courtesy Bill George.)

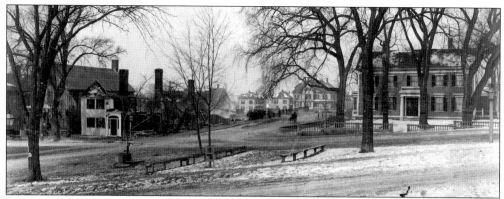

This is the scene on the morning of January 13, 1894, after a fire destroyed all of the commercial buildings on the west side of Central Street between Hammatt and Market Streets. Said to have started in the photography studio of George Dexter in the Jewett Block, the fire destroyed that building, the Wildes Block, Central Block, a small building belonging to Byron's News Service, and Jackson's Express office. The fire stopped after burning half of the William Heard House on the corner of Market and Central Streets. (Ipswich Historical Society.)

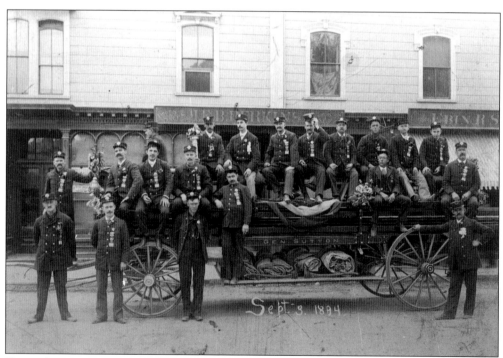

Shown here in 1894 in parade dress is the crew of the still hand-pulled ladder truck, General Sutton. (Ipswich Historical Society.)

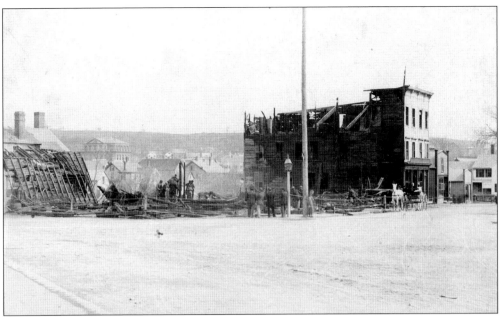

On April 17, 1894, only three months after the destructive fire on Central Street, the opposite end of Market Street at Depot Square was laid waste by fire. Firefighters had been delayed by a fire at Fall's coal yard when fire was discovered in the large dry goods and grocery store of Curtis Damon. The badly damaged Lord Building is on the right. Among other businesses destroyed were William H. Roberts, provisions; Clark & Gallagher, hairdressers; Louis Rubinovz, clothing; and the Salvation Army. After this loss, a vote to install a municipal water system, which had been defeated many times, was approved almost unanimously. (Ipswich Historical Society.)

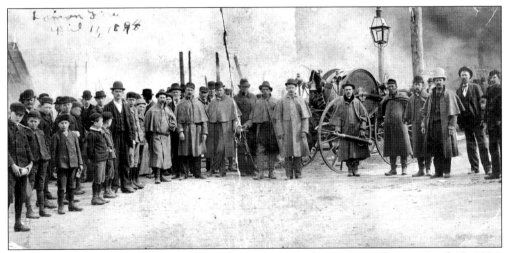

Although it is certain that this picture of the Damon Block ruins was taken on April 17, 1894, the hose reel and firemen's coats are of a style at least 50 years old and the locals did not have traditional fire hats. The tall hat on the apparent fire chief is from the Civil War era, but the presence and excitement of the young boys is timeless. (Ipswich Historical Society.)

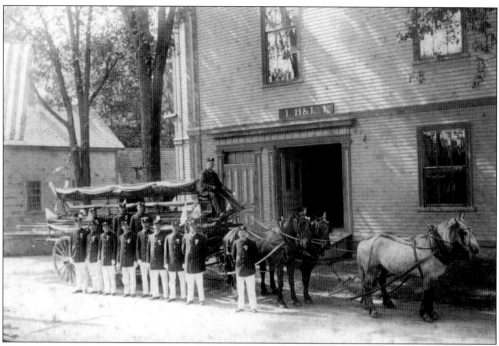

This view on Elm Street was taken *c.* 1906, when the General Sutton hook and ladder was housed in back of the Ipswich Town Hall. The fire truck has been converted to a horse-drawn vehicle, and the firefighters appear to be ready to march in a parade. (Courtesy Bill George.)

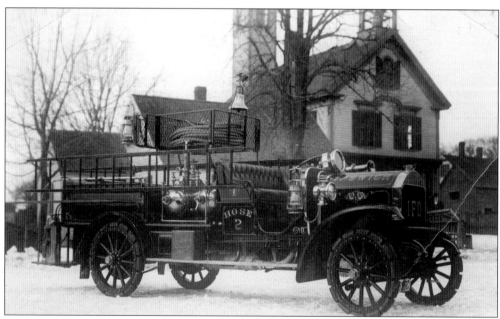

Ipswich fire protection had taken giant strides from the hand-pulled hose reel at the Depot Square fire of 1894 to Hose 2, purchased in 1912. This, the town's first mechanized fire truck, was photographed in front of the Lord's Square fire station. The building is still standing and is used as an antique shop. (Ipswich Historical Society.)

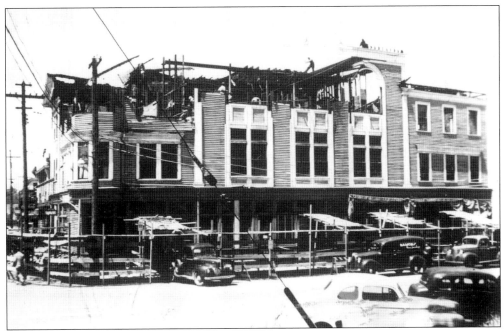

There have been three different Damon Blocks in Depot Square. The first burned in 1894. This picture shows the removal of the third floor after a destructive fire in June 1946. In turn, this reconstructed building, along with the buildings on either side of it, was destroyed in 1982. (Courtesy Wilbur Trask.)

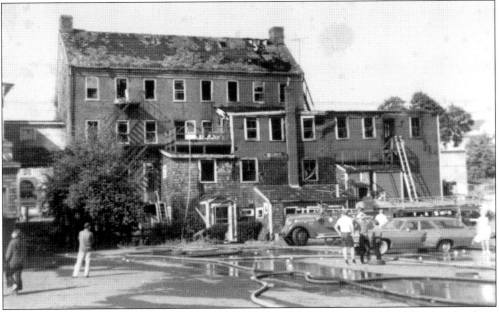

One of the most tragic fires in Ipswich was the 1969 destruction of the Hayes Hotel, in which four men died. The building was built in 1840 as a men's underwear factory, converted to a hotel and, at the time of the fire, was being used as a boardinghouse. This rear view of the lower level shows a small patio, which had a sign reading "Lakeside Lounge." (Courtesy Varrell Collection.)

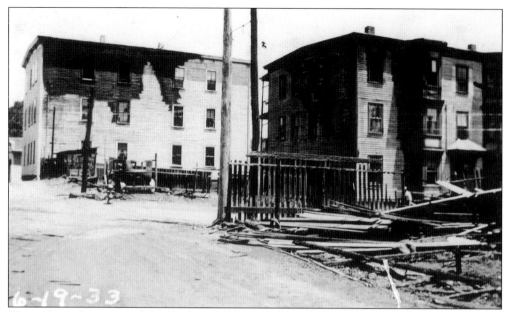

These charred remains of the Burke Heel Factory fire of June 1933 clearly show where that conflagration was contained. These buildings were repaired and still stand as apartments at Brown Square. (Courtesy Jim Tedford.)

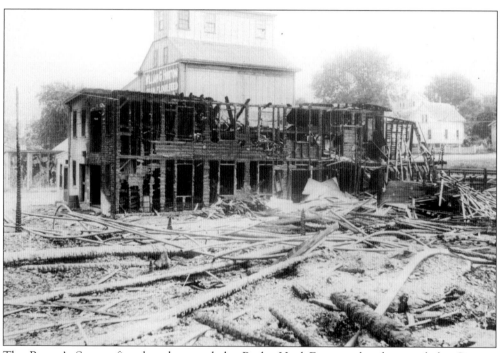

The Brown's Square fire that destroyed the Burke Heel Factory also destroyed the Canney Lumber Company. This scene shows the surviving Wirthmore Feeds grain elevator still standing as part of the Tedford and Martin lumber complex, which bought out Canney's in 1946. (Courtesy Bill George.)

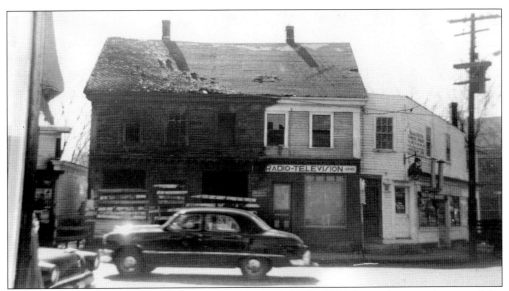

This scene of the Bailey Building, which burned in April 1956, shows the gutted ruins of the Butterfly Beauty Salon, run by a woman locally known as Madame Butterfly. The appearance of this corner of Market and Union Streets shows that, in 1956, downtown Ipswich had apparently missed the economic boat. However, in 1959, this building was replaced by a new F.W. Woolworth and, in 1996, that building was replaced by the current West Coast Video store. (Ipswich Historical Society.)

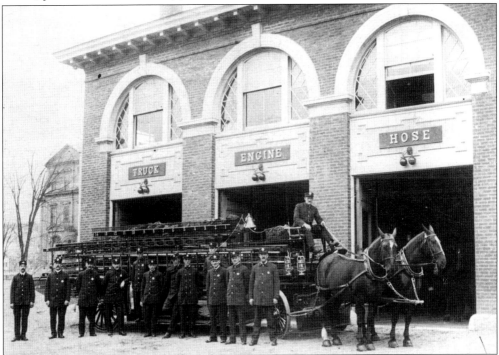

Shown here is the new Central Street Fire Station, completed in 1907. The hook and ladder "General Sutton," converted to a horse-drawn vehicle, serves as a backdrop for its proud professional crew. It was motorized in 1930. (Ipswich Historical Society.)

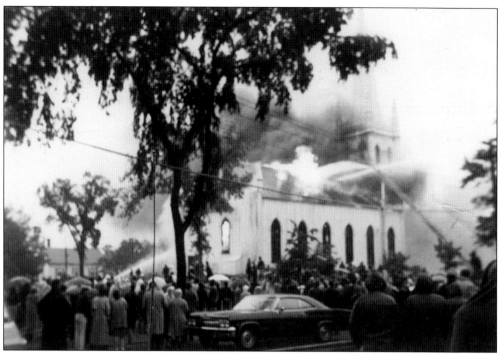

On the afternoon of June 18, 1965, the First Church of Ipswich on Town Hill was struck by lightning. Many artifacts were saved, but after a seven-hour battle, this church, built in 1847, was burned beyond repair. (Courtesy Wilbur Trask.)

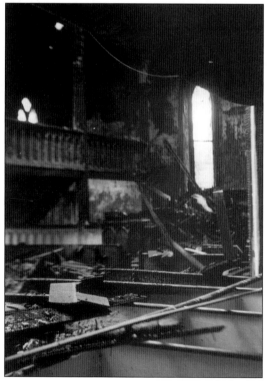

These are the charred remains of the fifth building of the First Church of Ipswich. (Courtesy Sandra Hanwell.)

## Six

# AUTHORS AND ARTISTS

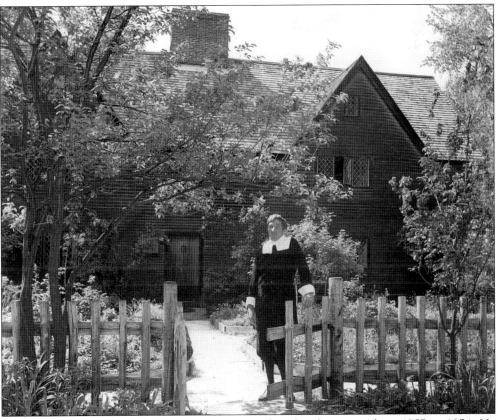

John Updike, Ipswich's Pulitzer Prize winning author, lived in town from 1957 to 1974. He often wrote about the town and wrote and participated in the 17th-Century Days pageant (pictured here at the Whipple House). Many consider his finest local contribution to be the best-selling novel *Couples*. It stood the town on its ear, as many speculated on which local inhabitants were represented by his most colorful characters. (Frederick Clow photograph, Ipswich Historical Society.)

Thomas Franklin Waters, the minister of the South Congregational Church from 1879 to 1909, was the author of *Ipswich in the Massachusetts Bay Colony*, a two-volume history of Ipswich. His research of documents and deeds has withstood the test of time. He was also the founder of the Ipswich Historical Society, and for many years the Heard House was called the Waters Memorial. (Ipswich Historical Society.)

For many, Kitty (Adele) Crockett Robertson was the best-loved local personality of her generation. Educated at Radcliffe, she had passionate feelings for the local environment and the town's more modest inhabitants. A well-known local newspaper reporter and selectwoman, she also wrote the highly acclaimed *Measuring Time—by an hourglass* and the posthumously published bestseller *The Orchard*. (Ipswich Historical Society.)

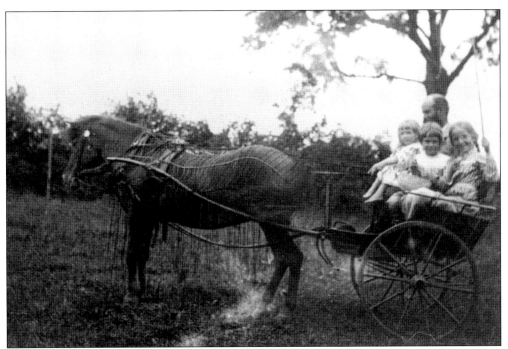

Dr. Charles Wendell Townsend was a resident of the doctors' summer colony on Argilla Road and a widely known authority on birds and their habitats. His books *Sand Dunes and Salt Marsh* and *Beach Grass* are regarded as classics on natural history and the environment. (Ipswich Historical Society.)

Sidney Shurcliff, the son of noted landscape architect Arthur Shurcliff, was a summer resident of Argilla Road. In 1959, he wrote *Upon the Road Argilla*, a fascinating, often humorous reminiscence describing how the neighbors spent their summers in Ipswich. (Courtesy Charles Shurcliff.)

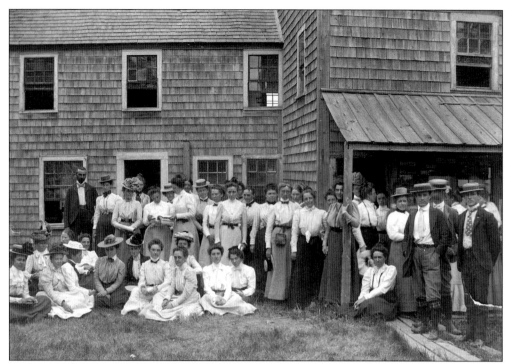

Arthur Wesley Dow is probably Ipswich's best-known artist. Born in Ipswich and educated in Paris, he is also noteworthy for his contributions to art education. For many years he conducted a summer art school at the Emerson-Howard House on Turkey Shore Road. Author of *Composition*, a book for art teachers and students, he was head of the fine arts department at Columbia Teachers College in New York City. (Ipswich Historical Society.)

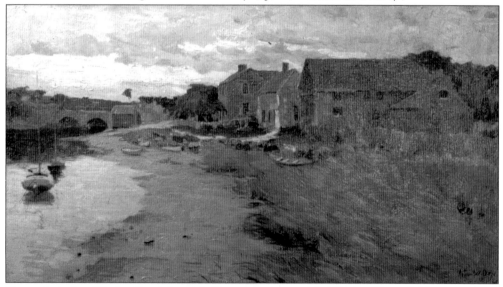

Shown is Arthur Wesley Dow's Ipswich River painting entitled *Turkey Shore*. Of the many local artists who painted in a similar style at beginning of the 20th century, Dow was the only one who was born and brought up in Ipswich. He let it be known that he considered the colorful lower river subjects his private preserve. (Courtesy First National Bank of Ipswich.)

Theodore Wendel was born in Ohio and trained in Europe. The Green Street Bridge in Ipswich was the subject of a painting of his, now in Boston's Museum of Fine Arts. Moving to Ipswich in 1899, he joined the local artist colony here. His son, Daniel Wendel, purchased the *c*. 1700 Ross Tavern and moved it from South Main Street to Jeffreys Neck Road, where it was restored to its First Period style. (Courtesy Whitney Wendel.)

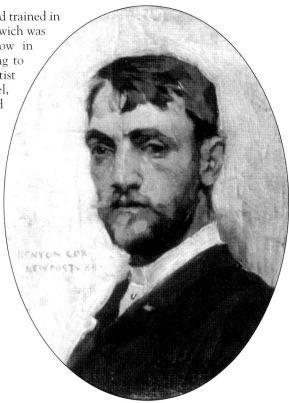

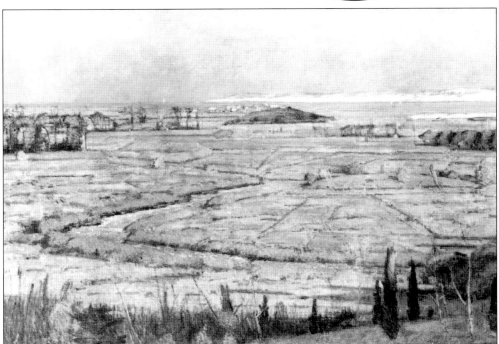

Shown is Theodore Wendel's painting *Ipswich Marshes from Heartbreak Hill*. Note Labor-in-Vain Creek winding through the marshes on its way to the sea. (Courtesy Whitney Wendel.)

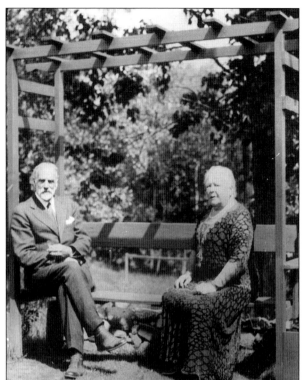

Ipswich artist Francis H. Richardson and his wife Frances Richardson are shown in the arbor at their home "Meadowview" on County Road. A talented artist, Richardson trained in Paris, maintained a Boston studio, and exhibited at major galleries and museums. (Courtesy Stephanie Richardson Gaskins.)

This Richardson painting, thought to be Candlewood Road, captures the charm of rural Ipswich in the early 1900s. (Courtesy Stephanie Richardson Gaskins.)

## *Seven*

# THE GREAT ESTATES

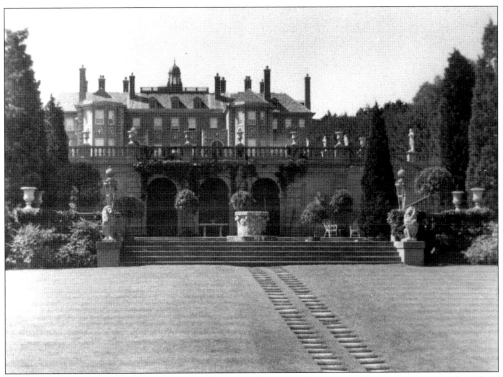

Castle Hill is no doubt the greatest of the great houses of Ipswich. This is the second building on the site. The first, an Italian Renaissance Revival villa, was torn down by Crane, and the Stuart-style house shown here was finished in 1928. The Crane estate overlooks the ocean on a remarkable 2,000-acre site. The other great houses of Ipswich are scattered throughout the town. (Arthur Shurcliff photograph, courtesy The Trustees of Reservations.)

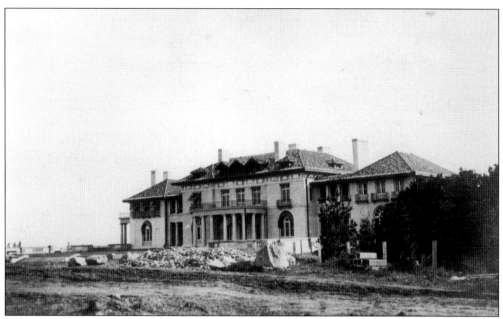

This picture, taken in 1911, shows the ocean side of the first Crane house (1910–1925) at Castle Hill before it was landscaped. The Cranes only used this house a few months each summer, as they had a similarly styled house at the Jekyll Island Club off the coast of Georgia that they used in the fall. (Courtesy The Trustees of Reservations.)

The Castle Hill Farm was originally granted to John Winthrop in 1638. In 1843, it was purchased by Manasseh Brown, whose son, John Burnham Brown, owned the property as it appears here. The property was purchased by Richard T. Crane Jr. in 1910. The building on the right is now known as the Brown Cottage and was recently restored as a bed and breakfast inn by The Trustees of Reservations. (Courtesy Bill George.)

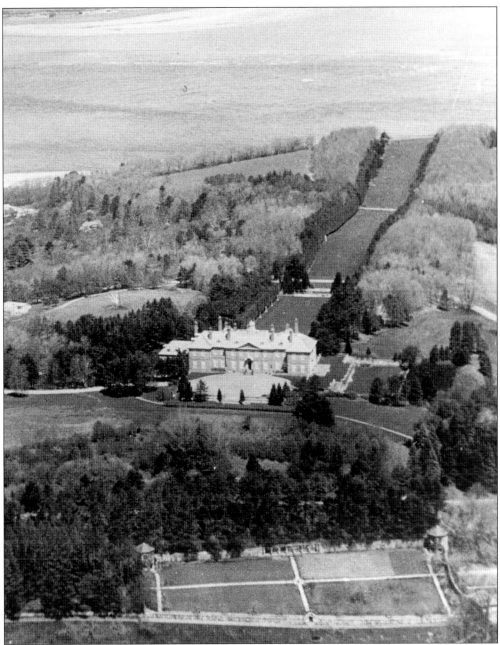

Landscaping was an important part of most great estates, and the landscaping at Castle Hill is matched by few homes in America. Before the property was purchased by the Cranes, carriage roads had been laid out by landscape architect Ernest Bowditch. Although the Boston firm of Olmsted Brothers did the original planning for Crane, the landscaping was completed by Ipswich summer resident and neighbor Arthur D. Shurcliff. Shown here is the Great House, the second mansion on the property, completed in 1928, and the Grand Allee, the Shurcliff-designed rolling lawn that stretches more than a half mile from the mansion to the ocean. In the background is the mouth of the Ipswich River and Little Neck. (Ipswich Historical Society.)

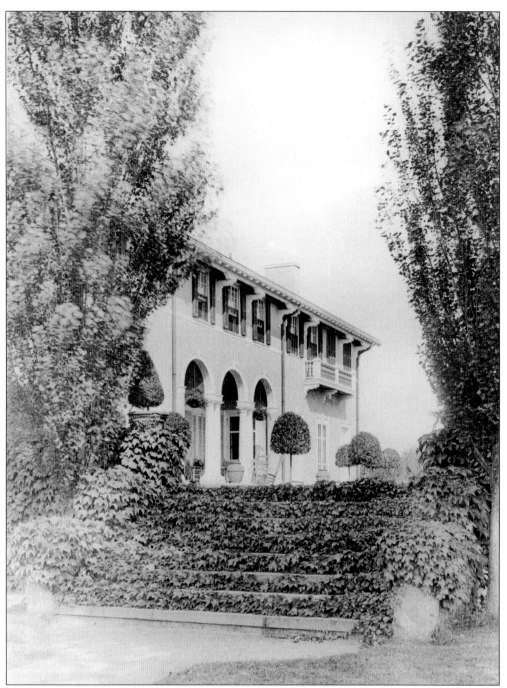

"Inglisby" was built as the summer home of Boston lawyer Charles P. Searle, whose winter home was on Commonwealth Avenue in Boston. Sold after the death of the Searles' son, it was purchased by the Tuckerman family and was leased at one time by actor Raymond Massey. It is currently on the grounds of the convent of the Sisters of Notre Dame on Jeffreys Neck Road. (Courtesy Society for the Preservation of New England Antiquities.)

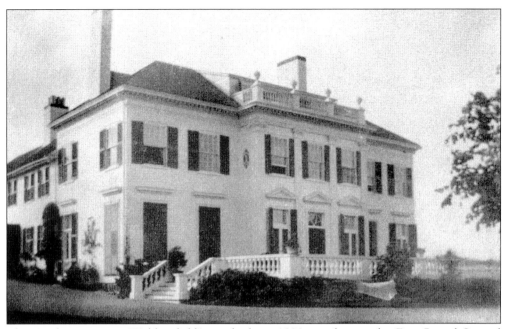

The Appleton estate "Waldingfield" was built in 1898, combining the First Period Samuel Appleton house (in the rear) with a modern front section. Almost completely destroyed by fire in December 1915, it was rebuilt out of concrete and steel as the "Hunting House" of the Myopia Hunt Club. (Courtesy Don Curiale.)

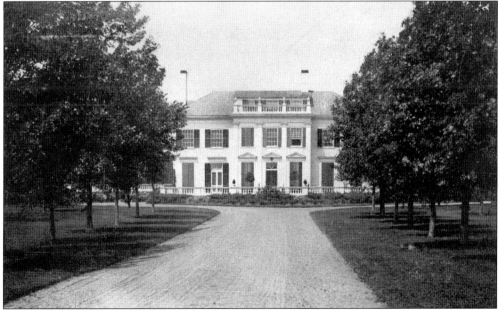

This is another view of "Waldingfield," built in 1898. (Courtesy Don Curiale.)

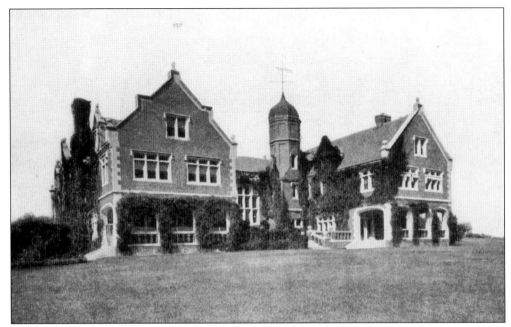

The Proctor Estate, on the south side of County Road, was built by James H. Proctor in 1895. In 1955, it became the Sacred Heart Juniorite, a Catholic seminary. Later it became the Don Bosco Retreat House, which it remained until 1999, when it became the home of New England Biolabs. (Ipswich Historical Society.)

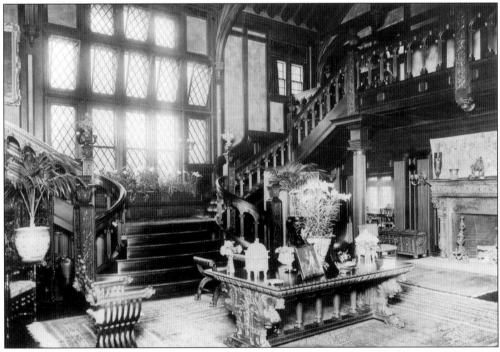

The stair hall at the Proctor Estate belies the fact that the estate was called a summer cottage. The Catholic order of Don Bosco purchased the estate in 1958 for a seminary and retreat house (Courtesy Society for the Preservation of New England Antiquities.)

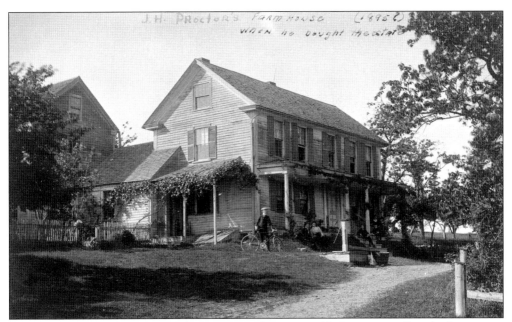

This comfortable house was on the property when James H. Proctor purchased what was to become the very grand Proctor Estate. It was used as the superintendent's house. (Ipswich Historical Society.)

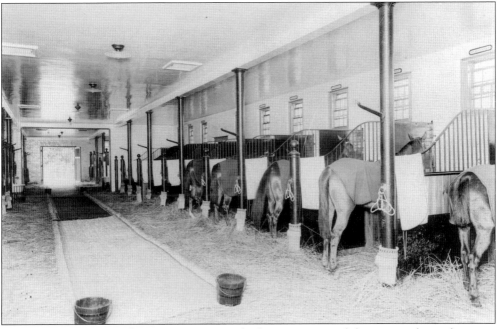

Although most of Ipswich's great estates were built just as automobiles were replacing horses as the primary means of transportation, riding and the nearby Myopia Hunt Club were very much a part of the summer social ritual. This is the stable at the Proctor Estate. After conversion of that property to a Catholic seminary, the stable became the dormitory and classrooms for the seminarians, and this tiled section of the building became the seminary gymnasium. (Courtesy Society for the Preservation of New England Antiquities.)

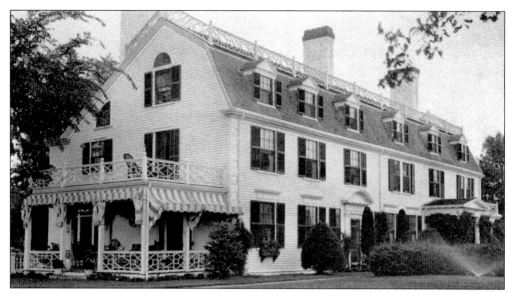

The "New House" at Appleton Farms was built by Francis R. Appleton in 1891, and it was last occupied by his mother, Fannie. Tradition says that due to a combination of taxes, maintenance, and a family disagreement as to who should occupy it, and under what conditions, it was torn down in 1950s to settle the problem once and for all. (Courtesy Don Curiale.)

During the Victorian era, when the owners of the great estates were in residence, Underhill's Corner, at the intersection of County and Waldingfield Roads, was the elegantly understated way to the various estates of the Appleton family. Picture the Tuckerman's Park Drag, currently in the carriage collection of the Ipswich Historical Society, passing here on the way to Appleton Farms. (Courtesy Don Curiale.)

It was a privileged life at the Randolph Appleton estate "Waldingfield," where Appleton was known to his peers as "Uncle Budd" and the butler, Robbins, served morning coffee on the back steps. (Courtesy Don Curiale.)

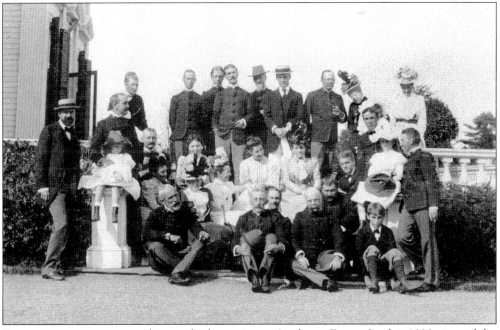

Frequent entertaining was the standard practice at Appleton Farms. In this 1898 view of the extended family and guests, the Appletons, who have a prominent military tradition from King Philip's War in 1675 through World War I, are seen entertaining officers during the Spanish-American War. (Courtesy Don Curiale.)

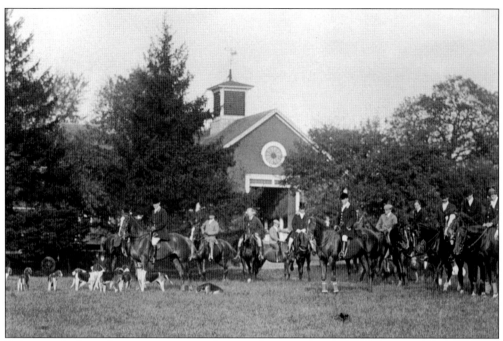

Riding to the hounds was a major ingredient in the summer social schedule for the inhabitants of the local great estates. Shown here, in front of the red barn at Appleton Farms, are many Rices, Proctors, Tuckermans, and Appletons. (Courtesy The Trustees of Reservations.)

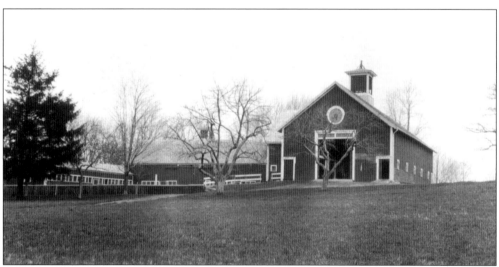

In a town where most of the farms had a large barn, few were as impressive as the red cow barn at Appleton Farms. Its oldest section, built in 1867, was struck by lightning and burned to the ground on August 3, 1943. The $25,000 loss would have been greater had not the prize herd of 40 Guernsey cows been out grazing at the time. (Courtesy The Trustees of Reservations.)

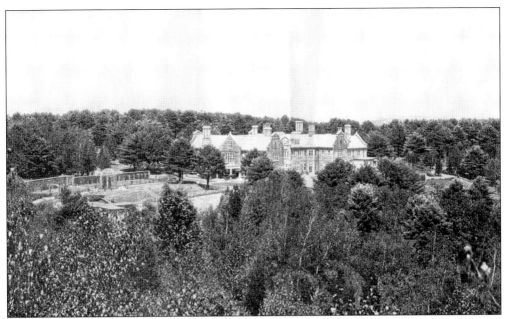

Turner Hill off Topsfield Road was built in 1903 as the year-round home of Boston industrialist Charles Rice, his wife, Anne Proctor Rice, and their three children. Designed by architect William G. Rantoul, it was styled after the Scottish estate Haddington Hall. From 1945 to 1997, the estate was the National Shrine and Seminary of Our Lady of La Salette. It is currently privately owned and being developed as an inn with first-class amenities. (Courtesy Turner Hill.)

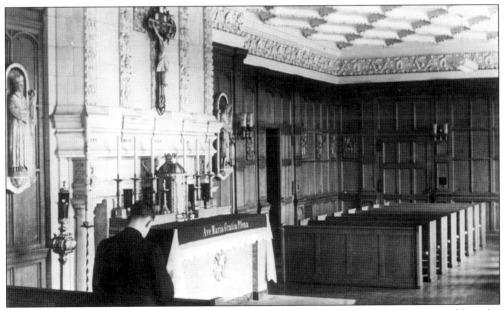

The Rice Estate at Turner Hill was one of three of Ipswich's great estates that was sold to the Catholic Church. Shown here is the Rices' former living room converted to a chapel. (Courtesy Martha Varrell.)

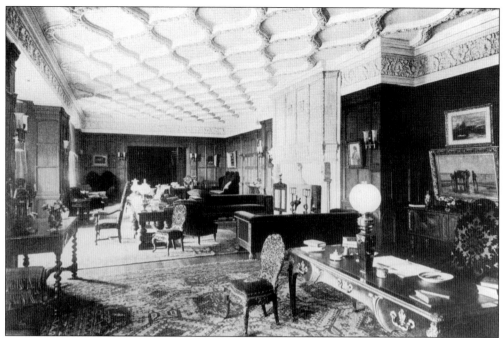

The living room at the 700-acre Turner Hill was the scene of frequent entertaining. It was also the scene of the 1914 wedding of Hilda Rice to Frederick Ayer and the funeral of Anne Rice who died in 1933 when thrown from a horse. (Courtesy Turner Hill.)

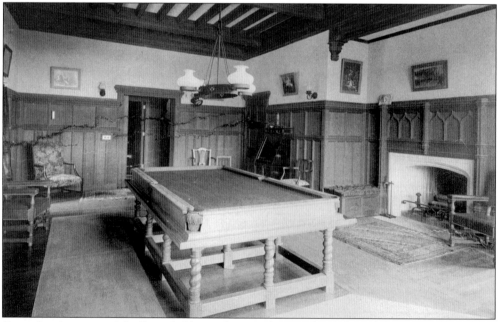

Once the classroom of the Rice children, who were home-schooled until they went to boarding school, the boys' room was the domain of sons Neil and Thomas Rice. Mrs. Rice arranged weekly parties for her children. The activities of the very athletic family included polo, swimming, squash, tennis, pool, bowling in the basement bowling alley, and games in the main house on rainy days. (Courtesy Turner Hill.)

# *Eight*
# ETHNIC DIVERSITY

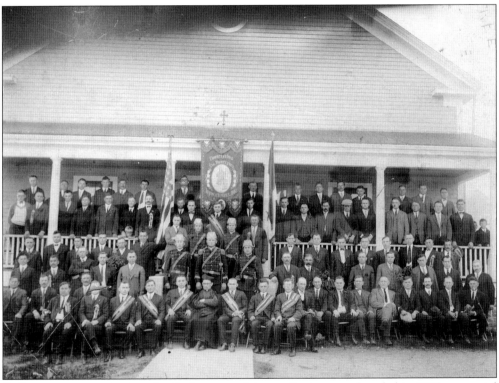

Still an active organization, the St. Lawrence Literary Society was founded in 1907 as a social club for Polish immigrants and to promote the learning of English. The men in the center, wearing military-style uniforms, were members of the Polish Roman Catholic Union (PRCU), an auxiliary group formed to enable members to buy group insurance through the Catholic Church. (Courtesy Ted Lezon.)

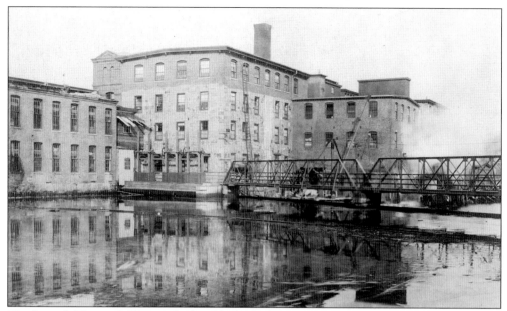

The Ipswich Hosiery Mills was the local hub of ethnic diversity. First employing New England girls wanting to get off the farm, it was later staffed by waves of Irish, French Canadian, Polish, and Greek immigrants, each willing to work for a little less than the group before them. Shown here is the dye house and the footbridge over the dam. (Ipswich Historical Society.)

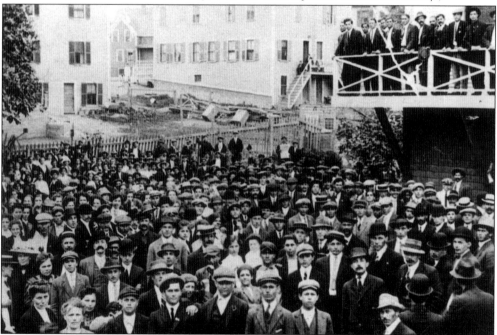

Shown here is a meeting of the Ipswich Mills workers during a strike in 1913. When International Workers of the World union organizers tried to prolong the strike, violence broke out on June 5, 1913, on what was to be known as "Bloody Tuesday," and a Greek woman was killed. Police patrols from many surrounding towns had to be called to restore order. (Ipswich Historical Society.)

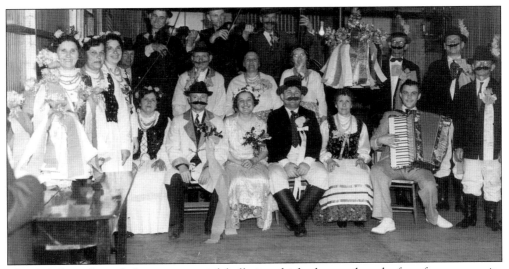

The Polish in Ipswich have two social halls in which they gathered often for community activities. Many are said to have come to Ipswich with musical talent, and they often produced their own variety shows. (Courtesy Ted Lezon.)

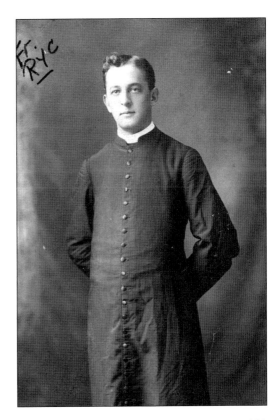

Father T. Charles Ryc, the first priest to serve the Polish community, came to Ipswich in 1908. (Courtesy Ted Lezon.)

Members of the choir of the Sacred Heart Catholic Church got into the spirit of their heritage by wearing Polish outfits. They are, from left to right, Joan Riley, Wanda Carlson, Frank Kasprzak, Louise Ciolek, Blanch Kmiec, Lou Krupanski, Rosalie Sweeney, Anna Goot, Alma Caren, and Helen Adamczyk. Ignacy Surowiec is in the back row but is not visible in the photograph. (Courtesy Wanda Carlson.)

The French Catholic Church of St. Stanislaus occupied its lower hall, shown here in 1912, and the upper church was completed in 1918. In 1925, the Sisters of Ste. Chretienne arrived to occupy the convent and teach in "St. Stan's" elementary school, which operated until 1970. (Courtesy Bill George.)

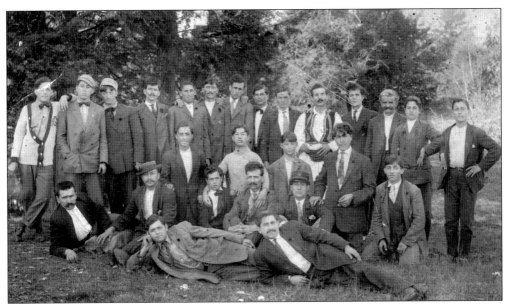

Shown here *c.* 1915 is one of the first picnics of the local Greek Logganiko Society. Named for the town from which most of Ipswich's Greek community emigrated to America, it was formed as a mutual aid, insurance, and charitable organization. In its earliest days, it even helped to raise money for return fare for those so desperately homesick they wanted to return to Greece. These popular picnics are still held as charitable fund-raisers on the weekend closest to July 20, the saint's day of the Greek patron saint, Elias. (Courtesy Jane Bokron.)

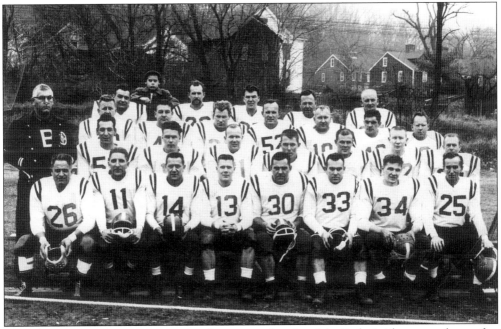

A melting pot of awesome contenders were the Ipswich Red Raiders, members of a semiprofessional football league active during the late 1930s and 1940s. Made up of Ipswich men in their twenties and early thirties, they played teams from the surrounding cities and as far north as Augusta, Maine. (Courtesy Ted Lezon.)

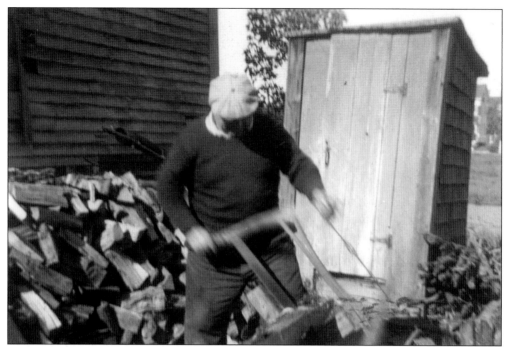

Bremslaw Bogel gets some exercise at his woodpile. Not dictated by ethnic origin, at the beginning of the last century, most Ipswich backyards included the kitchen woodpile and the family privy. (Courtesy Ted Lezon.)

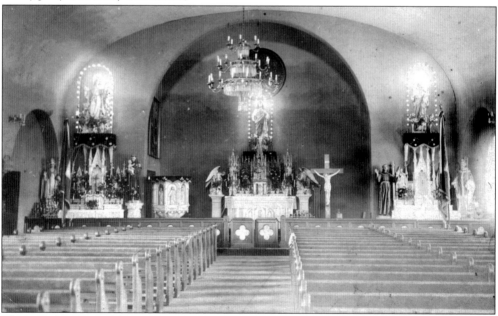

This is a 1930 view of the interior of the Sacred Heart Polish Catholic Church, founded in 1908 so that the Polish-speaking immigrants could hear the homily in their native language. Sacred Heart and St. Stanislaus French Catholic Church were consolidated with St. Joseph's (the original Irish Catholic Church) in 1999, and the three churches became Our Lady of Hope. (Courtesy Ted Lezon.)

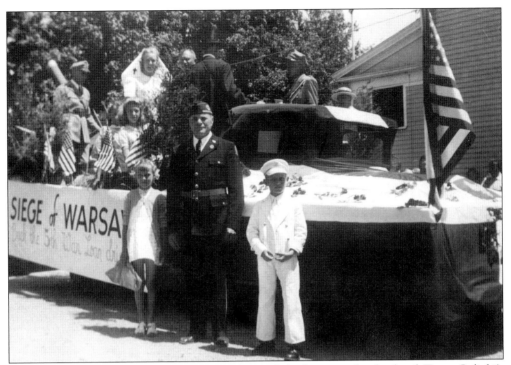

The 1944 Fourth of July parade included a Polish float on the back of Tony Galicki's 1934 Ford hay truck. Standing in front of the float with their father are Frances Galicki Richards, current town clerk; Tony Galicki, a World War I veteran; and Donald Galicki. (Courtesy Fran Galicki Richards.)

During construction of the first Crane Estate at Castle Hill (1909–1911), the Italian craftsmen who had been brought over to do the work were housed in barracks near the beach. The Crane family album refers to this housing as "Italian 'Villas' on Pier Road." Little Neck is in the background. (Courtesy The Trustees of Reservations.)

John Krajeski remembers spending summers on Hammatt Street in the late 1930s, when the neighborhood ladies had their own "League of Nations" on his grandmother's porch. Speaking broken but recognizable English were his grandmother Mrs. Sojka, Polish; Mrs. Lampropolos, Greek; and Mrs. Kaufman and Mrs. Adleman, Jewish. Long before the term became common, he recalls they were practicing their own "global warming." (Courtesy Bill George.)

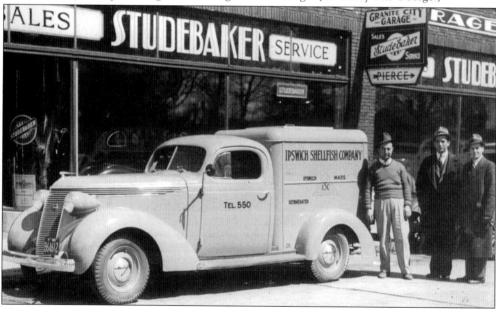

This is the first delivery truck of the Ipswich Shellfish Company, the paramount success story of the local Greek community. Founded by George Pappas in 1935, when he actually dug the clams himself, the company has grown to become one of the leading seafood processing and distributing companies in the United States. (Courtesy Ipswich Shellfish.)

# *Nine*
# REST AND RELAXATION

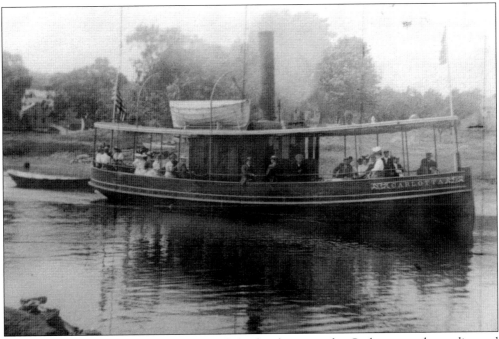

Of all the many pleasure boats that plied the local waters, the *Carlotta* was the undisputed Queen of the Ipswich River. Built at Edward's shipyard in 1878 for Capt. Nathaniel Burnham and drugstore owner George Brown, it served the Ipswich community until it was sold in 1914. In addition to daily summer trips to Eagle Hill, Little Neck, and Plum Island, it also took special excursions to Salisbury Beach and the Isles of Shoals, off the coast of New Hampshire. (Courtesy Bill George.)

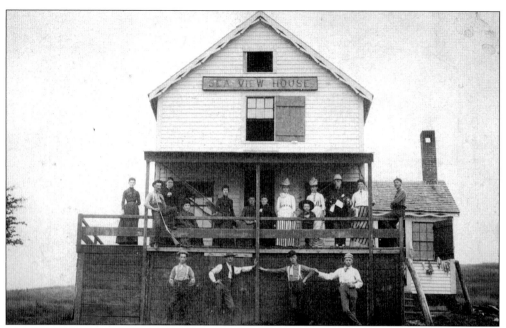

The Sea View House on Little Neck was built by Ipswich real estate developer Frederick Willcomb. Often rented for weekend excursions, it had the classic piazza, a wood stove on which one could make a chowder, and space to change bathing suits. It gave the women an excuse to get gussied up and the men a chance to relax in their shirtsleeves. (Ipswich Historical Society.)

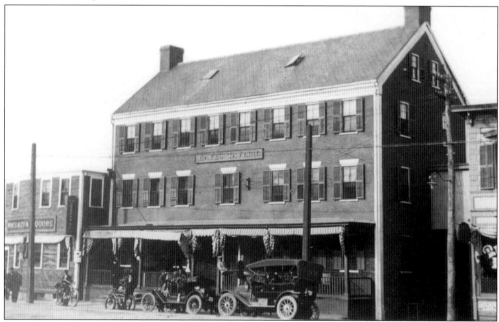

The Hayes Tavern had originally been built by the Peatfield brothers *c.* 1840. It is said to have been the first men's underwear factory in the country. Converted to Hayes Tavern by John W. Hayes in 1885, it was later sold to Thomas Broderick, who changed the name to Hayes Hotel. It was considered to be the wettest watering hole north of Boston. (Courtesy Bill George.)

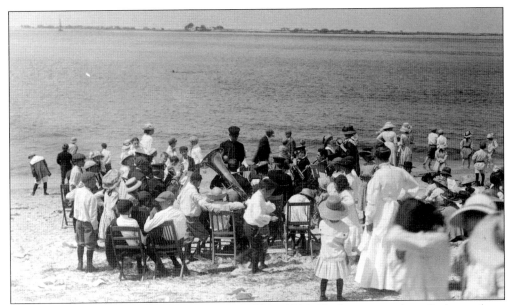

The first Crane's Beach school picnic was held in 1911. Tradition says that all the students traveled to the beach on the *Carlotta*, but half went in large wagons called barges. The crew of the Cranes' yacht served as lifeguards, large tents protected the children from the sun, and the United Shoe Machinery band provided entertainment. It was so successful that it is an annual event to the present time, still funded in part by a bequest from the Crane estate. (Ipswich Historical Society.)

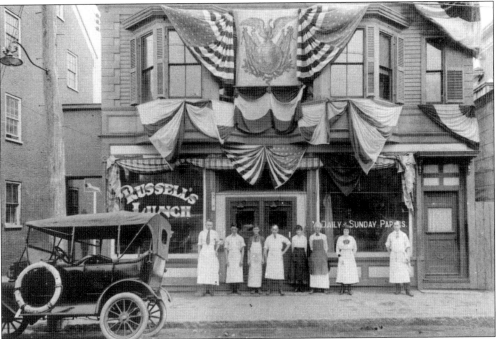

Some say that Russell's Lunch, next to the Hayes Hotel in Depot Square, was the home of the fried clam. This restaurant burned in 1932. Before the Depot Square fire of 1982, the building was the infamous watering hole Bannon's. (Ipswich Historical Society.)

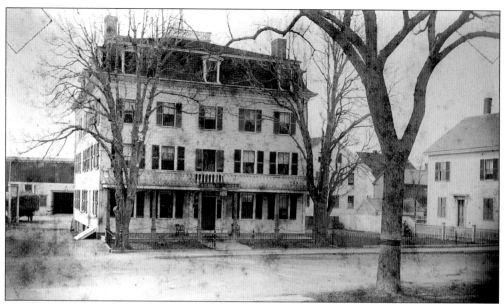

This is the Agawam House on Meeting House Green after its days as an overnight stop on the Eastern Stage Line, when it housed lawyers practicing at the local courts, such as Daniel Webster and the visiting dignitary the Marquis de Lafayette. One of the owners at this time was Jeremiah Prescott, who went on to become a railroad conductor and superintendent of Boston's Public Transportation System and the Eastern Railroad. (Ipswich Historical Society.)

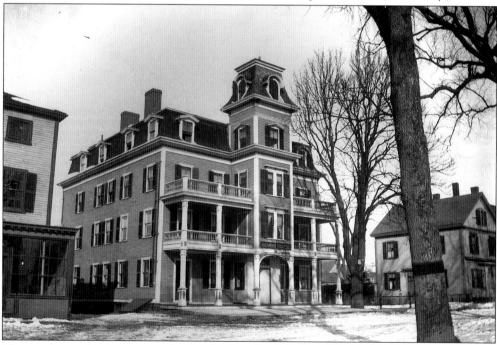

The porches and tower were probably added to the front façade of the Agawam House during the ownership of William G. Brown. An inn since 1806, when Nathaniel Treadwell was innkeeper, this building was the town's first-class hotel until the 1930s, when it was converted to apartments. (Ipswich Historical Society.)

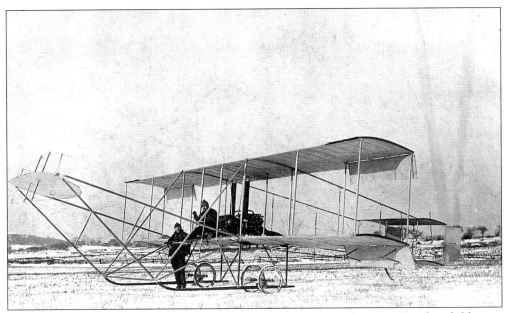

This 1910 view of a very early Burgess biplane was taken at the Essex Road airfield, near Northgate Road. Said to have been modified many times as a result of crashes, the plane was manufactured in Marblehead. The pilot is Charles K. Hamilton, a pioneer aircraft and hot-air balloon daredevil, pilot, and stunt flyer. (Ipswich Historical Society.)

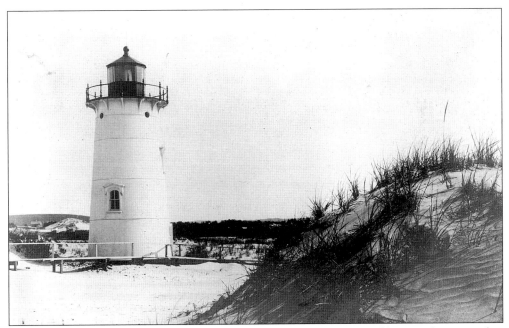

From 1838 until 1938, Ipswich had a typical picturesque lighthouse and keeper's house at what was then known as Lakeman's Beach. Operated for many years by Benjamin Ellsworth, the revolving white light was removed in 1934 for economy reasons. Four years later, because of the drifting sand, the federal government moved the steel lighthouse to Edgartown on Martha's Vineyard. The lighthouse keeper's house burned in October 1973. (Ipswich Historical Society.)

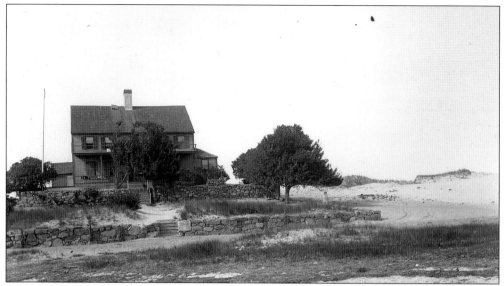

In 1911, when the Cranes' first estate was being completed, there were still two small hotels at what was to become Crane's Beach. This building was called Woodbury's for G. Loring Woodbury, from whom the Cranes bought the property. Rented at the time to a family from Ohio, it caught fire and burned to the ground. The second building, used as a cranberry warehouse, was saved by the new motorized Hose 2 fire truck. (Courtesy Society for the Preservation of New England Antiquities.)

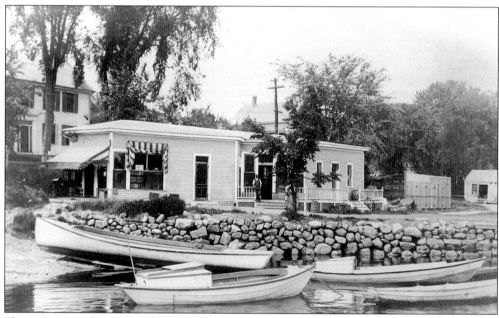

Shown here at what is now the town wharf is Alonzo Brown's refreshment parlor and pool hall. At one time it was also Claxton's Sea Grill, a summer restaurant serving clam and lobster dinners. During the winter Claxton operated a restaurant on Market Street next to the Strand Theater. (Courtesy Bill George.)

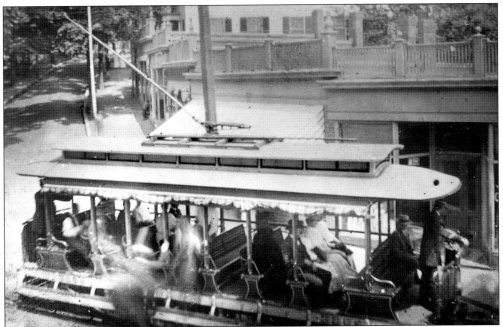

This open trolley is stopped in Market Square with the Jones Building in the background. For the first quarter of the last century, one could travel almost anywhere on the New England coast by trolley; however, it was much slower than the railroad, and the local area was too sparsely settled for the trolley companies to make any money. For anyone who lived in Ipswich from 1900 to 1919, trolley cars were one of the most nostalgic reminders of summers past. (Ipswich Historical Society.)

For men and boys at least, the Ipswich River was the municipal pool and the community bathhouse on a warm summer day at the beginning of the 20th century. Girls were also there, separated by a bend in the river. (Courtesy Varrell Collection.)

This is Harry Brown, superintendent of the Lower Mill, on the grounds of the Rogers Manse. Not only was a sprightly rig a means of transportation, it was also a status symbol, whether owned or rented from Brown's livery stable. In 1879, the carriage swells created the Agawam Trotting Park on the site of Doyon School. At that time the part of town where Linebrook Road crossed Bull Brook was known as Brookdale. (Ipswich Historical Society.)

It appears that "Oakley" was located on Plum Island, another classic example of an Ipswich summer by the sea. (Courtesy Bill George.)

These are the remains of the *Ada K. Damon*, wrecked at Crane's Beach in 1909. Another memorable local shipwreck was that of the brig *Falconer,* lost here on December 17, 1847. During that wreck 36 were rescued, but 17 were lost, and 12 bodies were buried in a common grave at the North Cemetery under a memorial stone. (Courtesy Elma Quill.)

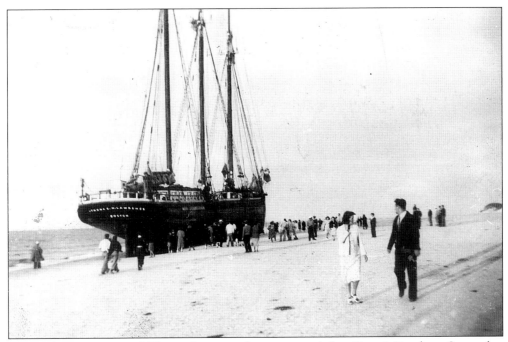

This is the 374-ton vessel *Thomas Lawrence* that was stranded at Crane's Beach on September 4, 1939. Later, a channel was dug and the ship was refloated. The schooner *Deposit* was wrecked at the same spot, then called Lakeman's Beach, with the loss of seven crewmen in 1839. (Courtesy Wilbur Trask.)

The small hotels at Ipswich Bluff on Plum Island were a favorite destination of locals on the steamer *Carlotta* with Capt. Nat Burnham. (Ipswich Historical Society.)

These women on the porch of the Willow Cottage at Ipswich Bluff are certainly overdressed by today's standards and no doubt not inclined to let their hair down, but still enjoying their summer outing *c*. 1900. (Ipswich Historical Society.)

This idyllic summer scene is at Grape Island on the Ipswich portion of Plum Island, a favorite destination for Ipswich residents. In 1900, Grape Island had a hotel and enough year-round residents to support a school. The community slowly died out during the early 20th century, and the island is now a federal wildlife reservation. (Ipswich Historical Society.)

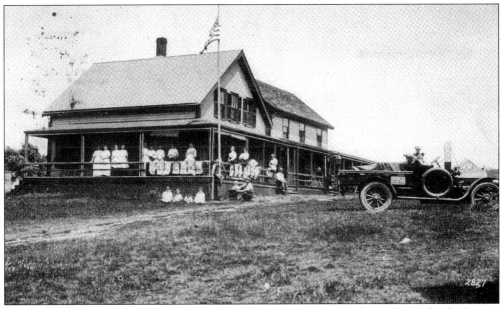

At the beginning of the 20th century, Ipswich had summer hotels at Plum Island, Crane's Beach, and Little Neck—all of which were very modest. This is the Little Neck Hotel, store, and post office, at one time operated by Fred and Helen Byron. The People's Express had a branch office in the store. (Courtesy Bette Savage.)

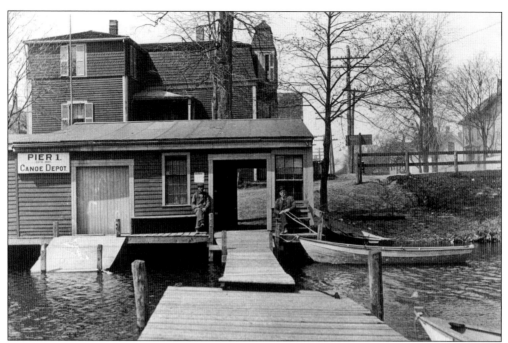

Goodhue's Boathouse was located on the river at the end of Peatfield Street. Operated for many years by Samuel Goodhue at Pier 1 on the upper river, in addition to renting boats and canoes, this hangout for local sports also featured a billiard table. (Ipswich Historical Society.)

On May 13, 1930, fire severely damaged the auditorium of the Ipswich Opera House. On September 11, 1930, after three months of renovation, it reopened as the Strand Theater. The opening featured a benefit for the Benjamin Stickney Cable Hospital, with Cornelius Crane showing films of his cruise to the South Pacific on his yacht *Illyria*. (Ipswich Historical Society.)

## Ten
# SEEMS LIKE YESTERDAY

This idyllic New England scene existed for a very short time between the construction of the Bicentennial Pond as a memorial to local activist Sally Lunt Weatherall and the fire that destroyed the former South Congregational Church in December 1977. (Courtesy Wilbur Trask.)

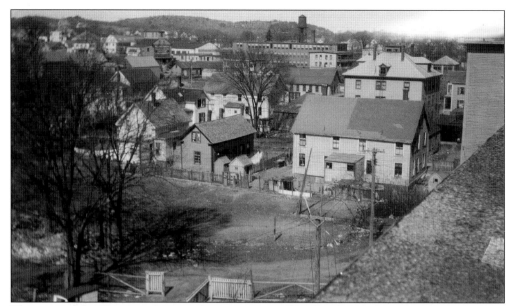

This view of the Hammatt Street–Brown Square neighborhood was taken sometime before the Brown Square fire of 1933. The foreground is now the site of the municipal parking lot. Some of the buildings are gone, including the Burke Heel Factory in the background, but the former Franklin House Hotel, with its hipped roof, remains on Hammatt Street as an apartment house. (Ipswich Historical Society.)

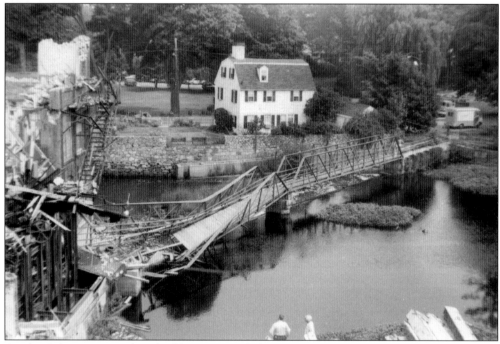

As the Sylvania paint shop building—part of the former Ipswich Hosiery Mills—was being demolished in September 1973, a collapsing wall destroyed the footbridge across the Ipswich River dam. Plans are currently under way to reconstruct this bridge as part of the River Walk. (Courtesy Wilbur Trask.)

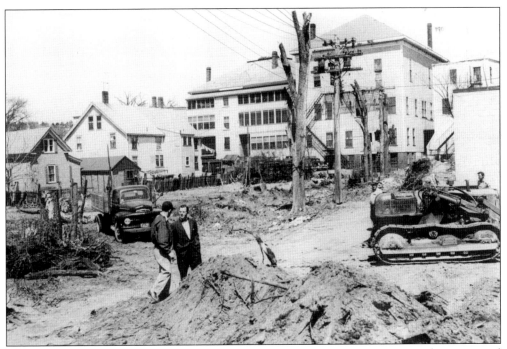

In 1958, the town moved a few buildings and graded a wasteland to create the municipal parking lot between Market and Hammatt Streets. (Courtesy Bill George.)

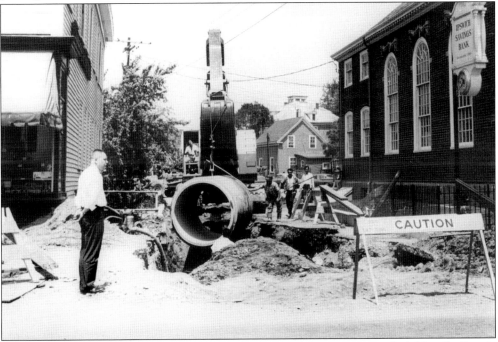

For years people had complained about Farley's Brook, sometimes called Heard's Brook, essentially an open sewer that stagnated behind the Central Street houses between the Liberty Street railroad crossing and downtown. In 1961, town meeting finally appropriated $50,000 to put Farley's Brook into an underground culvert. (Courtesy Bill George.)

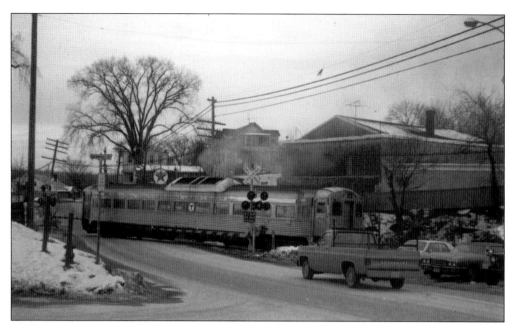

This picture from the 1970s shows a Boston & Maine Railroad Budliner crossing Topsfield Road. During the final days before the Commonwealth assumed operation of commuter rail, the equipment got so bad that the self-propelled Budliners had to be pulled by engines, the double-paned glass became so opaque that you could not see out, and the sloshing water that collected between the broken panes of glass made you feel as if you were riding in a storm at sea. (Courtesy Wilbur Trask.)

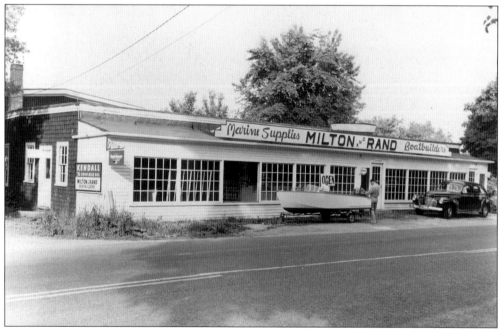

Following the death of Ralph Burnham in 1938, his Antiques Trading Post, on High Street near Kimball Avenue, became the home of the Milton and Rand Marine Supply store, where the very popular Hi-Liner boats were manufactured. (Ipswich Historical Society.)

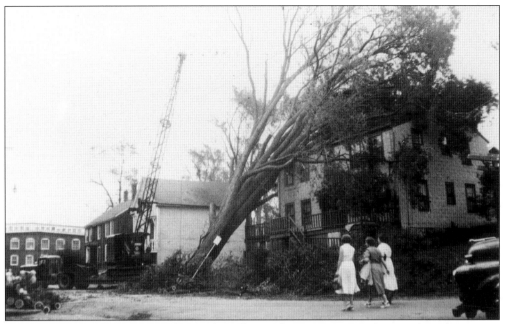

This scene on Union Street shows the effects of Hurricane Carol in 1954. This street, with its Civil War-era name, led from Market Street to the gate of the Ipswich Mills. It was formerly the location of mill boardinghouses, blacksmith shops, and livery stables. (Courtesy Wilbur Trask.)

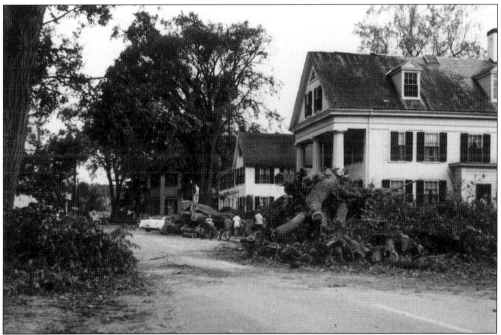

At one time the town's principal streets were bordered by graceful arches of elm trees. A combination of hurricanes and Dutch elm disease changed that part of the local ambiance forever. This scene of destruction at the South Green was caused by Hurricane Carol, in 1954. (Ipswich Historical Society.)

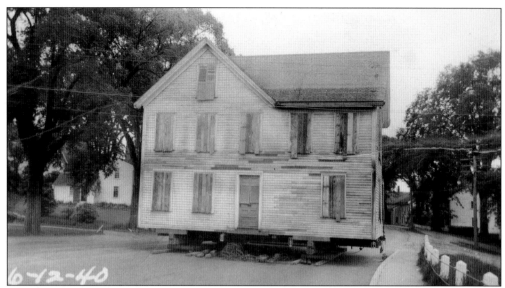

Until *c.* 1950, it was often thought to be cheaper to move buildings than to tear them down and start anew. Over the years many Ipswich houses have been moved like chessmen on a board, some more than once. In 1940, the Richards' house was moved from Central Street, across from the end of Liberty Street, to Kimball Avenue. (Courtesy Ken Richards.)

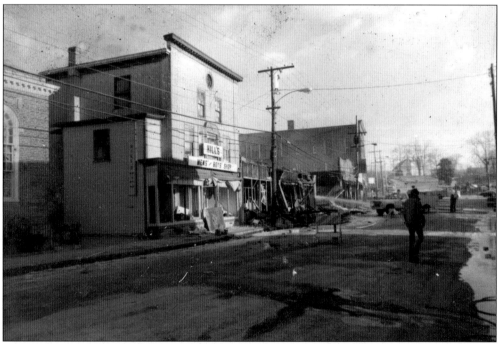

In January 1980, flames destroyed Hill's Clothing Store in a general alarm fire that was finally contained by firemen from 11 surrounding communities. First opened in 1929 and considered the heart of downtown Ipswich, the store was rebuilt after a fire sale that included many scorched garments and blocks of frozen merchandise. The rebuilt Hill's closed in 1994. (Courtesy Taffy Hill.)

The Methodist church, built in 1859, lost its steeple to dry rot and lightning in 1973. The new steeple, an exact replica of the old, conceals a cellular telephone tower but restores the skyline of Town Hill. (Courtesy Varrell Collection.)

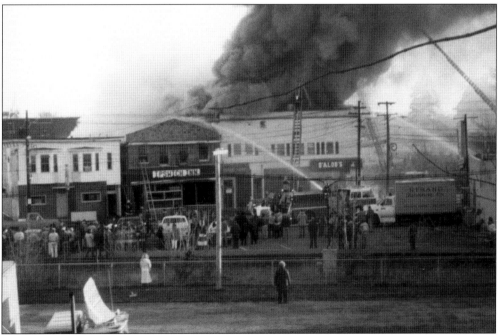

As the French say, *déjà vu*. The Damon Block burned for the third time in December 1982. As part of the approval to demolish the Victorian railroad station in 1958, the cinder block Strand Furniture Building, on the far right, included a pathetic little closet of a railroad waiting room, furnished with three discarded sofas. (Courtesy Ted Lezon.)

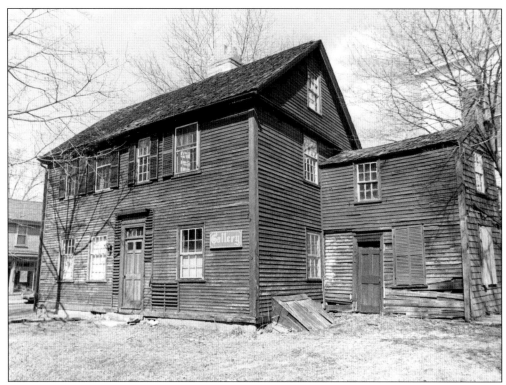

This is the Hall-Haskell House, currently the Ipswich Visitors Center, before it was restored by a committee of volunteers beginning in 1982. Built c. 1819 and at one time having a street-floor shop, it later became part of the Heard estate. Its last resident was the widow of John Heard, who died in 1930. (Courtesy Terri Stephens.)

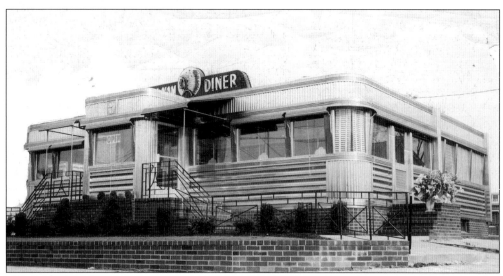

This is the last Agawam Diner to remain in Ipswich. One of four different Agawam Diners to sit on the slope across from the railroad station, it was moved to Peabody in 1963. (Zaharis Studio, Ipswich Historical Society.)

In 1975, there was a colorful parade down Town Hill to celebrate the 200th anniversary of Benedict Arnold's march to Quebec. The weather did not cooperate as members of the parade marched in the pouring rain, but as they reached the crossroads of Quint's Corner and Market Square, it was a vivid reminder of Ipswich's long role in American history. (Courtesy Varrell Collection.)

Quint's Drugstore closed in 1989, but many locals still think of the site as Quint's Corner. This corner and Ipswich are still crossroads of American history, and all roads lead to a great future. (Courtesy Varrell Collection.)

# ACKNOWLEDGMENTS

The progress of this project has resulted from the very positive experience of many different individuals enthusiastically contributing the missing pieces of the town's more recent pictorial history. Just when you think you have seen it all, some unexpected forgotten gem appears.

I would especially like to thank Stephanie Gaskins, president, and Elizabeth Redmond, director of the Ipswich Historical Society, for their strong support for this project and for allowing me to pick up and run with this ball. I sincerely hope I have conveyed the excitement I have for this subject.

We are forever grateful to Bill George for allowing us to use his outstanding photographs of his hometown, which he has collected for most of his adult life. We are also in debt to Wilbur Trask for consistently taking and sharing pictures of the many events that most take for granted.

Ipswich is fortunate to be closely associated with a number of professional historical organizations and properties. This project has been greatly enhanced by being able to share the collections of these organizations. We must thank Susan Hill Dolan of The Trustees of Reservations, Lorna Condon of the Society for the Preservation of New England Antiquities, Victor Dyer of the Ipswich Public Library, and Marc Teatum of the Peabody Essex Museum.

The integrity of the text owes much to longtime residents. Special thanks belongs to Pat Tyler, always willing to take on special tasks, including typing and editing many drafts of this text; her crew of volunteers at the Ipswich Historical Society for cataloging their collection over the years; and to Ken and Fran Richards and Sue Nelson for their depth of knowledge in ensuring the accuracy of the text.

The diversity of this project would not have been possible without the support and interest of many individuals. Among them are Barbara Breaker, Jane Bokron, Wanda Carlson, Don Curiale, Donald Fouser, Sandra Hanwell, Marion Kilgour, John Krajeski, Chuck Kaucher, Ted Lezon, Taffy Hill, Bill Markos, Charlie Passales, Elma Quill, Bette Savage, Charles Shurcliff, Terri Stephens, Jim Tedford, Immie Thayer, Ted Raymond, and Martha Varrell.

Finally, we thank those individuals who gave us clues to desired pictures, as well as others who tried to assist us but have been currently unable to locate the missing views. May they and others continue in this quest to pictorially document our town's past.

—William M. Varrell